IMAGES
of America

KENTUCKY'S
COVERED BRIDGES

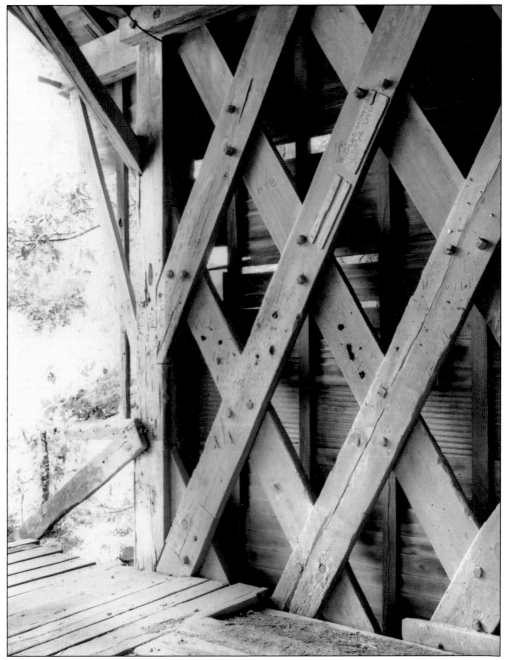

SLATE CREEK BRIDGE. This April 24, 1952, photograph shows construction of the Town lattice truss. (Courtesy Transylvania University Library, John Thierman Collection.)

ON THE COVER: The workers of the Bower Bridge Company pose for a photograph at the portal of the Switzer Bridge in summer 1906. From left to right are (first row, seated) unidentified; (second row, standing) the Jones brothers (owners of the former mill at Switzer), David Jones (no relation), Louis Bower, two unidentified workers, and Franklin County Judge James H. Polsgrove. (Bower Bridge Company photograph, Laughlin Collection.)

IMAGES
of America

KENTUCKY'S
COVERED BRIDGES

Robert W. M. Laughlin
and Melissa C. Jurgensen

ARCADIA
PUBLISHING

Published by Arcadia Publishing
Charleston, South Carolina

Printed in the United States of America

Library of Congress Catalog Card Number: 2006936423

For all general information contact Arcadia Publishing at:
Telephone 843-853-2070
Fax 843-853-0044
E-mail sales@arcadiapublishing.com
For customer service and orders:
Toll-Free 1-888-313-2665

Visit us on the Internet at www.arcadiapublishing.com

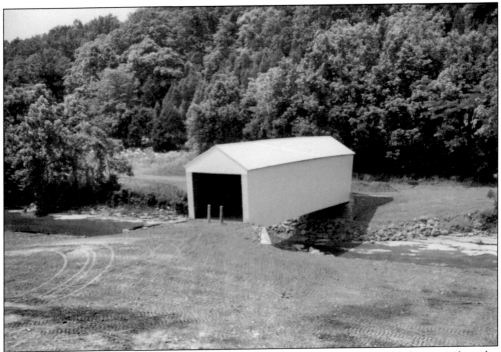

WALCOTT BRIDGE. Because of the damage that the 117-year-old bridge had received in the March 1997 flood, a decision was made by the Kentucky Transportation Cabinet to move it to a less-flood-prone crossing 400 yards east of its original location. It was originally stated that most of the original timbers—including hand-hewn timbers from the earlier 1824 bridge—would be used in the reconstruction. Only a few were actually used to make the span that some consider to be an entirely new bridge. (Jurgensen photograph.)

CONTENTS

ACKNOWLEDGMENTS

The earliest days of covered bridge preservation centered on the fight to save the Camp Nelson Bridge in the 1920s. Since that time, thousands of interested individuals have left their marks trying to preserve these Bluegrass timbered tunnels. The authors wish to thank a number of these individuals who have helped make this volume possible.

First thank you to Lauren Bobier, Kendra Allen, and Barbie Halaby of Arcadia Publishing for making this a reality. The following individuals are thanked for making contributions and sacrifices to covered bridge preservation, the pursuit of history, and interest in this project: Louis Stockton Bower family; Howard and Genna Lou Murray; Ann Mason; Mayor Dixie Hibbs of Bardstown, Kentucky; Luther Hargis; Dave Kratt; Danny Woods; Rob Bostrom; Greg Harler; Ann Preston; Henry and Shirley Gurley; Jim and Catherine Reinoehl; Tom Scherer; Kelly R. Bernstein; Jennifer Sizemore; Ari Buchwald; Ray Gehron; Raymond Webb; Lois Barnes; Louise Roach; Virginia Sandidge; Donald Hines; Sean Collins; Jeff Vansant; Mike Switzer; Dorothy May Switzer; Lucy Richardson; Buddy Lewis; Jack Distler; C. C. Gardner; Dr. Fred Coy; Jeanne Hodge; Eleanor Jenkins; Bill Davis; Darrell Maines; Whitie and Bonnie Gray; Bridget Striker; Matt Becher; Suzanne Shephard; David Muth; Bill Penn; Harold Slade; Phillip Naff; Donna Sisk; Debbie Dennie, Falmouth Outlook; Mary Winter and Nathan Prichard, Kentucky Historical Society, retired; B. J. Gooch, Transylvania University; Charlene Smith, Kentucky Historical Society; Jim Holmberg and Becky Rice, Filson Historical Society; Dorothy Griffin and Kathleen Kenney, Greenup County Public Library; Sharon Bidwell, *Louisville Courier-Journal*; Andy Anderson and Bill Carner, University of Louisville; Patrick Kennedy; Bob Polsgrove; Brian Harney; Opet; Roger and Janet Ach; Mike and Tommie Bennett; Jane Laughlin; Shelby Riggs; and R. W. B. Laughlin.

Special thanks to Erin Powell for the extensive use of her computer and allowing herself to be dragged to archives, abutments, and alcoves around Kentucky.

Melissa Jurgensen would like to extend personal thanks to friends and family who gave her ongoing encouragement and support throughout the writing of this volume: Alisyn Camerota; Mercedes Colwin; Lis Wiehl; Kathy Stigers; Anita Vogel; Carol McKinley; Paul Callan; Maj. Gen. Paul and Muffin Vallely; Lt. Col. Bill Cowan; Gerald McCullouch; Skip O'Brien; David Asman; Margaret Young; Mike, Judy, and Brian Jurgensen. Thanks to Billy Perraut for starting this obsession.

Special thanks to those who have taken their time to search records and have provided photographs for this volume; many are the only known images of certain bridges. Images from the authors' collections appear without credit.

For questions or comments about the content herein or about any Kentucky covered bridge, please contact Robert W.M. Laughlin at Laughlin.Robert@gmail.com and Melissa Jurgensen through KYCoveredBridges.org.

FOREWORD

Historians seldom have the privilege of creating a benchmark work linking three centuries on a subject of such cultural and architectural significance as Walter Laughlin and Melissa Jurgensen's *Kentucky's Covered Bridges.*

In that respect, this book was a collector's item at the moment of inception.

Scattered photographs of long-forgotten Kentucky covered bridges may occasionally surface in old scrapbooks or individual collections. Yet nowhere is there known to exist a more complete archival record of Kentucky's once-numerous covered bridges than in this compilation.

Like J. Winston Coleman's *Stagecoach Days in the Bluegrass*, Robert M. Rennick's *Kentucky Place Names*, or John Kleber's *Kentucky Encyclopedia*, Laughlin and Jurgensen's *Kentucky's Covered Bridges* is destined to be a reference of lasting importance.

Kentucky's covered bridges were among the commonwealth's most memorable time portals to that romantic era when horsepower was defined not by cubic inches but by hoofbeats.

My own lifelong love affair with the state's covered bridges began during the early 1950s on a scenic back road in the outer Bluegrass, near the Lincoln–Garrard County line.

The Hubble Road meandered past rolling farmscapes and the rustic Hubble Store, then along a wooded river bluff and into a gentle descent to what could have been a calendar photograph—the Hubble Road Covered Bridge over the Dix River.

The usual hum of tires on pavement ceased abruptly as our farm truck glided across the groaning timbers through the latticework of supports, past decades of dates and initials, aging remnants of political and carnival posters, and declarations of love and contempt left by unseen hands and the blades of many pocketknives.

I can recall peering wide-eyed over the dashboard into the twilight, heart racing, as beams of the headlights swept into the curve and were swallowed up by what seemed a giant, yawning tunnel. To my great delight, my father would always blow the horn mid-span, and my parents might recall their covered bridge memories as we left the bridge behind in the shadows.

All these years, my parents, Delbert and Lucille Crawford, have kept a rusted three-foot length of iron bracing that had been salvaged from the covered bridge over Hanging Fork Creek, a Dix River tributary that bordered our farm. The bridge had stood for many years at the end of a "creek road" that opened onto U.S. 150 between Danville and Stanford. The old Hanging Fork Covered Bridge was demolished for the building of a new bridge during the early 1940s, before I came along.

Nearly all the covered bridges in the area were extinct when I was a youngster, except the Hubble Road Covered Bridge over the Dix River. One night while I was still a boy, someone set fire to that last bridge, and it was destroyed.

When I grew older and became a journalist, my fondness for Kentucky's covered bridges was magnified by memories of the timbered tunnel of my childhood and of its unfortunate demise.

Although I realized the impracticality of preserving and maintaining large covered bridges, it always seemed a shame that, of the more than 700 covered bridges that once existed in Kentucky,

we managed to save only 13 for later generations to enjoy. Surely a small portion of the billions in transportation dollars spent on expressway cloverleafs could have been set aside for the preservation of a few more of these historic and scenic landmarks.

Like many other Kentucky journalists over the decades—including my *Courier-Journal* predecessors the late Alan Trout and Joe Creason—I have attempted to focus public awareness on the cultural and architectural worth of Kentucky's covered bridges when possible and to help others in their covered bridge preservation efforts.

Ironically, not until Laughlin and Jurgensen invited me to foreword their splendid covered bridge history would I discover that they had found not only several remarkable photographs of the bridge that I had crossed as a youngster, but also the only photograph I have seen of the covered bridge across the Salt River at Glensboro in Anderson County. The southern end of the Glensboro Bridge abutted the entrance to a small river bluff farm that is now my property.

This history also contains my parents' photograph of the Hanging Fork Bridge that was located at the end of our farm road before I was born.

If you are a native Kentuckian, or have lived near any of this state's many streams, somewhere in this book you will likely find reference to a covered bridge linked to your past.

My hope is that, in beginning this important archive with their own collections of Kentucky covered bridge photographs and records, Laughlin and Jurgensen have laid the groundwork for the discovery of still more fascinating facts and images regarding the sturdy, roofed, wooden bridges that transported several generations from horses and buggies to the horseless carriage.

Kentucky's Covered Bridges helps fill an important, unfinished chapter in Kentucky's rich history—and will most certainly occupy a long and productive shelf life in the libraries of future generations whose ancestors crossed the bridges between this book's covers.

—Byron Crawford
Kentucky Columnist
Courier-Journal

INTRODUCTION

This journey through timbered tunnels to times past began over 200 years ago with Kentucky's first covered bridge. It matured with the works of engineering pioneers named Town, Burr, Wernwag, Long, Stone, Hockensmith, Carothers, Bower, and others. It was nurtured during dark times by historians such as Rosalie Wells, author of *Covered Bridges of America*; Richard Sanders Allen, founder of the National Society for the Preservation of Covered Bridges (NSPCB); John Diehl, developer of the covered bridge numbering system; Paul Atkinson and L. K. Patton, founders of the Kentucky Covered Bridge Association (KCBA); Louis Stockton Bower, Kentucky's last covered bridge builder; *Louisville Courier-Journal* columnists Alan Trout, Joe Creason, and Byron Crawford; Kentucky historian J. Winston Coleman; Lynn Vaughn; John and Sue Thierman; Phyllis and David Brandenburg; Miriam Woolfolk; Joe Conwill; and Vernon White. The names of all who have made contributions to covered bridge preservation would fill more than this single volume.

For the authors, the journey began long after the heyday of covered bridges in Kentucky had passed and the spans themselves had passed almost entirely from the scene. Walter Laughlin became interested in Kentucky's covered bridges at an early age beginning with visits to Franklin County's Switzer Bridge. At the age of five, he was given his first collection of Kentucky covered bridge photographs by Lynn Vaughn. Over the next 34 years, it has grown into the largest single collection of Kentucky covered bridge photographs and ephemera to exist. Melissa Jurgensen became interested in covered bridges as a teenager, when her family moved to a rural area where a neighbor well versed in local history, Billy Perraut, told her of the nearby Colville Bridge in Bourbon County. Her photographs and writings have appeared in numerous venues, and she was granted exclusive access to the reconstruction of the Switzer Bridge after the March 1997 flood. In 2005, she developed KYCoveredBridges.org, the first Web site devoted to the comprehensive history of Kentucky's covered bridges.

This volume is not intended to be a complete record of Kentucky's covered bridges. Of the over 700 timbered tunnels known to have once existed in the Bluegrass State, photographs of slightly more than 130 have been discovered. Jacob Bower, father of Louis and grandfather of Stock, began, in the 1860s, the family tradition of photographing the covered bridges built or repaired by the Bower Bridge Company. His collection was lost when fire destroyed the family home in the 1890s. Portions of the collection later begun by Louis Bower survive and document much of the company's work in the early 20th century. Iron sounded the early death knell for covered bridges everywhere. Seemingly stronger and believed to require less maintenance than wood, iron replaced many serviceable covered bridges in the early 20th century, when photography was becoming an affordable amateur pastime. Until almost gone, the covered bridge was often considered an expendable, forgettable part of history not worthy of the price of film.

It is credible that many more than the 700 known covered bridges once existed in the commonwealth, but records have been destroyed, lost, or discarded, or have disintegrated to the point of illegibility. These factors—coupled with fading memories, incorrectly identified

photographs, phantom bridges, duplicate listings, and the continuing passing from the scene of residents of the covered bridge era—make a truly comprehensive history an unlikely eventuality. This volume is intended to gather what has been found and present an enjoyable experience to and perhaps evoke a happy memory in the reader.

Terms that are readily known to covered bridge enthusiasts will frequently appear in these chapters. For the uninitiated, camber is a rise built into the structure of a bridge from the ends to the center that allows the truss to compress into the abutments or piers without sagging. A covered bridge with or without an arch will be built with camber. Live load is the weight of traffic as it crosses the structure; dead load is the weight of the bridge. The chord is the longitudinal timber that frames the top and bottom sills of a truss. Compression members are the diagonal bracings in a truss system. As a load is carried by a bridge, these timbers squeeze or compress. Tension members are the vertical bracings and pull when under load. A buttress is internal or external bracing designed to resist lateral movement of the truss. Double barrel bridges are constructed to accommodate two lanes of travel in opposite directions; the lanes are divided by a center truss. Shelter panels are extensions of the roof and siding that protect the chord ends from weather. Condemnation of a bridge does not mean that it is scheduled for replacement or necessarily closed to traffic, only that the governing body (city, county, state) no longer accepts responsibility and using the structure is "at your own risk."

In 1926, the Kentucky Highway Department began a program to increase the live load capacity of covered bridges on the major highways known as the Red Lines, so called because they appeared in red on early maps. By removing three tons of siding from a bridge with a capacity of four tons, the capacity could be increased to seven tons. To replace the protection of siding, the trusses were painted with white lead, but paint did not adequately protect the joints of the timbers from the effects of alternate wettings and dryings, and the bridges quickly deteriorated. P.E. stands for Professional Engineer.

Some readers of this volume will recognize at least 12 omissions of existing covered bridges. These are in fact not authentic covered bridges but are known as Romantic Shelters. For a covered bridge to be authentic, it must have an integrated truss structure that carries both the live and dead loads of the bridge. A Romantic Shelter resembles a covered bridge, but the structure and traffic are supported by trestlework or by floor beams. These sometimes have a truss structure, but it is mostly decorative and does not carry any load other than the roof. At least one Romantic Shelter in Kentucky carries an authentic covered bridge pedigree. A Romantic Shelter recently built in Owen County was constructed using structural steel salvaged after the Natlee Bridge burned in 1954. The steel stringers had been used to replace one covered approach span in 1948.

Kentucky's 120 counties are divided into 15 regions known as Area Development Districts (ADDs). The chapters herein are named for these areas. The counties of 13 are known to have once contained covered bridges, but no photographs of any in the Jackson Purchase, Cumberland Valley, or Green River ADDs have been discovered. No covered bridges have been discovered to have ever existed in the counties of the Big Sandy and Kentucky River ADDs. In total, 94 of Kentucky's 120 counties are known to have once contained covered bridges.

The expense of stone bridge construction necessitated the development of the wood truss in the early days of this young country. Roofing and siding were economic measures to ensure that these bridges would survive. Wood gave way to iron and steel, iron and steel to concrete, and as bridge engineering enters the 21st century, concrete is beginning to give way to stronger and lighter materials. It seems doubtful that any future historian or author will ever lament the passing of unadorned structures of cement and asphalt, but then again, it may have seemed just as unlikely 100 years ago that anyone would ever care about a covered bridge.

One

PIONEERS OF PRESERVATION

Covered bridge preservation in Kentucky began in earnest in 1952 when John and Sue Thierman wrote "The Beautiful and the Doomed" for the *Courier-Journal Sunday Magazine*. Spurred by this renewed interest, in 1953, the Kentucky Highway Department charged Lynn Vaughn with the duty of cataloging the remaining covered bridges on the state highway system. Vaughn mapped many forgotten spans over the next 40 years and was a respected historian until his death in 2001.

The Kentucky Covered Bridge Association (KCBA) was founded in 1964 by Paul Atkinson and L. K. Patton of Fort Thomas, Kentucky. Patton is an accomplished historian. He has been a member of the Kentucky Civil War Round Table and the American Association for State and Local History and is a past president of the Northern Kentucky Historical Society. His achievements extend beyond the realm of history. He holds four college degrees, is a 32nd Degree Mason, and has sung with the Cincinnati Summer Opera.

Louis Stockton "Stock" Bower was the "Grand Old Man" of Kentucky's covered bridges. Stock began helping his father build and repair covered bridges before his 10th birthday and was apprenticed at 15. He was an infantry captain during World War II and saw action at Normandy. Stock was an invaluable asset in the preservation of Kentucky's covered bridges, and an era truly passed with his death on April 28, 1995, four days after his 90th birthday.

In the 1970s and 1980s, Miriam Woolfolk of Lexington and Vernon White of Bowling Green carried preservation efforts in Kentucky. Miriam, an accomplished artist, first printed her book of drawings of the remaining timbered tunnels in 1977 and continuously petitioned the state throughout these decades to "do something" to preserve these spans. Vernon, in 1983, published *Covered Bridges: Focus on Kentucky*, the first work to view these remaining bridges with attention paid to the construction details.

Covered bridges in Kentucky owe an incalculable debt to the numerous individuals who ever lamented the passing of even one. These pioneers of preservation ensured that the efforts were not in vain.

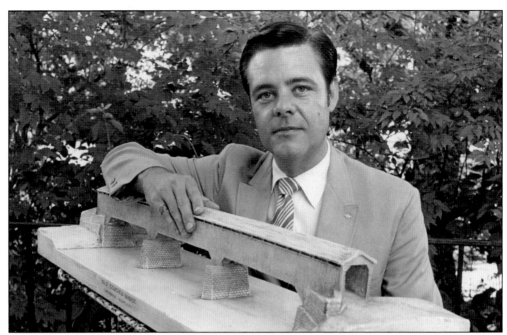

KCBA FOUNDER/EXECUTIVE DIRECTOR L. K. PATTON, PH.D. In 1934, the Cynthiana Covered Bridge was surveyed for the Historic American Buildings Survey of the U.S. Department of the Interior. Several scale plaster models of the bridge were produced. Two of these models are on display in the Cynthiana–Harrison County Museum. This model was presented to Patton in the 1960s.

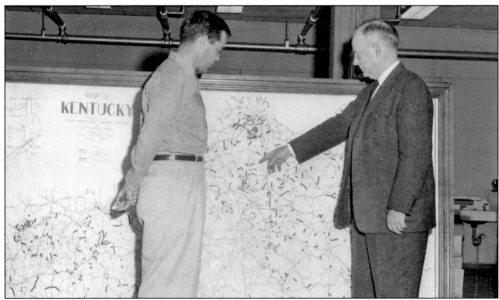

LYNN VAUGHN. This c. 1953 photograph shows Lynn Vaughn in front of a Kentucky highway map. The gentleman on the right is George D. Aaron. Vaughn retired from the Division of Planning as manager of the Cartographic Section after over 40 years of service to state government. Most Kentucky County Highway Maps were, and still are, unofficially referred to as "Lynn Vaughn Maps." Lynn Vaughn died at the age of 77 on May 14, 2001. (Courtesy Leesa Parrish.)

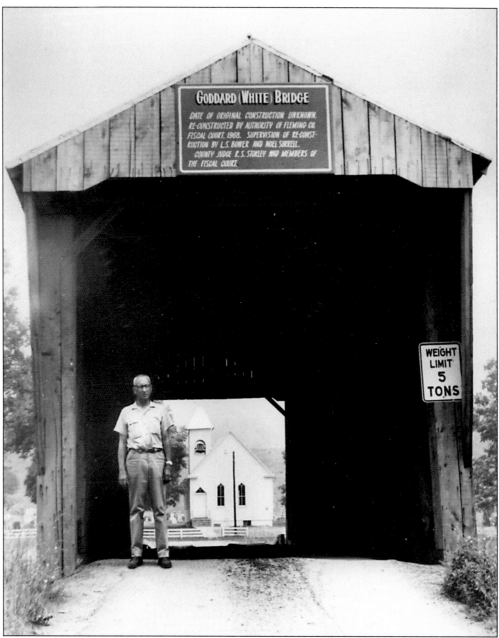

STOCK BOWER. A 1968 photograph of Kentucky's last covered bridge builder, Louis Stockton Bower of Flemingsburg, shows him in front of the then newly restored Goddard Bridge. Jacob Bower founded the Bower Bridge Company, later of Maysville, Kentucky, and its legacy passed from Jacob to his son Louis and finally, in 1936, when his father died from injuries sustained in an automobile accident, to the third and last generation, Stock. (Courtesy Miriam Woolfolk.)

MIRIAM WOOLFOLK. Miriam R. Lamy Woolfolk has many interests in addition to covered bridges. She is an accomplished artist and writer and has in the past taught art to the Donovan Scholars at the University of Kentucky. Since 1992, she has edited *Pegasus*, the journal of the Kentucky State Poetry Society. Her booklet of her own drawings, also titled *Kentucky's Covered Bridges*, has been in print since 1977.

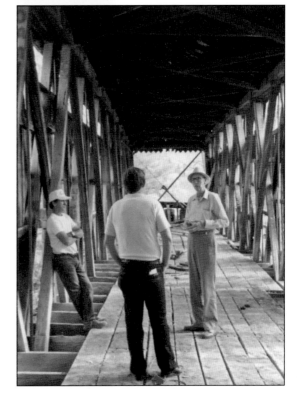

VERNON WHITE. A 1991 photograph taken during the first restoration of Franklin County's Switzer Bridge shows, from left to right, LeRoy Wood, contractor; Luther Hargis, P.E.; and Vernon White. White holds undergraduate and graduate degrees in sociology from the University of Louisville and the University of Tennessee respectively. He is a professor emeritus of sociology at Western Kentucky University. (Laughlin photograph.)

Two

NORTHERN KENTUCKY

The Northern Kentucky Area Development District encompasses Boone, Campbell, Carroll, Gallatin, Grant, Kenton, Owen, and Pendleton Counties. At one time, the areas that would eventually become these eight counties contained covered bridges, but as the state developed, bridges that had been in one county found themselves in or at another. Two of Kentucky's most significant covered bridges existed in this area: Kentucky's first reported covered bridge and Kentucky's longest covered bridge. Many small and forgotten spans crossed such streams as Bullock, Woolper, Snag, Willow, and Big Sugar Creeks. A covered bridge over Banklick Creek overlooked downtown Cincinnati until the 1920s. Larger and well-remembered spans were on the old 3L (Louisville, Lexington, and Latonia) Highway, which was privately built and believed to have been so named because it was the artery that carried horsemen and sports to the commonwealth's largest racetracks.

Highway bridge development in Northern Kentucky seemed to move in the opposite direction as the rest of the commonwealth. Unlike those in most counties, many of Northern Kentucky's covered bridges that survived well into the 20th century were on major highways. Several significant covered bridges on these Red Lines remained in use in the 1920s and 1930s. Bridges at Falmouth and Morgan carried traffic into the 1940s.

Northern Kentucky is known as the home of Barney Kroger, founder of the Kroger grocery store chain; breweries; and the "sin city" past of Newport. It was the home of the Kentucky Covered Bridge Association, and since the early 1990s, Northern Kentucky has been generally regarded as a developmentally progressive area. However, no resident of or visitor to the top of the state has been able to cross a timbered tunnel in over 50 years. The last covered bridge in the Northern Kentucky ADD was destroyed by an arsonist's match in 1954.

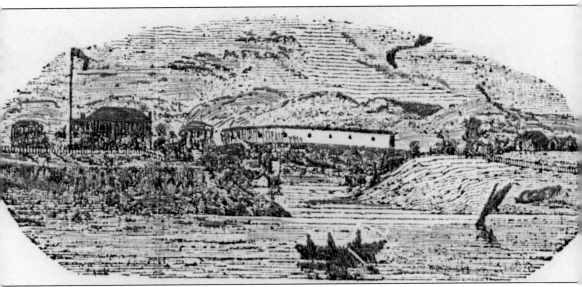

NEWPORT BARRACKS BRIDGE. The only known image of what is reported to have been Kentucky's first covered bridge is this engraving of the span over the mouth of the Licking River between Newport and Covington at the Campbell–Kenton County line. The Newport Barracks was established in 1803, and the bridge is mentioned in the *Old Minute Book*, which records the daily activities of the army post. If rumors can be verified that the bridge was built in 1804, it would have preceded Timothy Palmer's "Permanent Bridge" built at Philadelphia in 1805, regarded as America's first covered bridge.

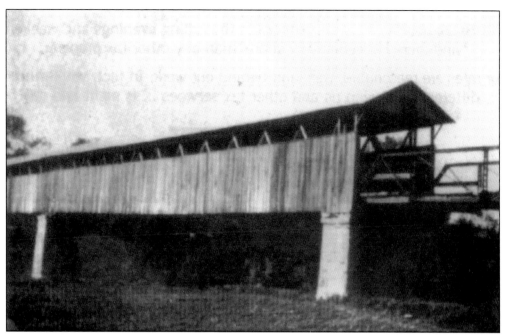

SANDERS BRIDGE. This is one of the only known photographs depicting the Sanders Bridge with its siding. (Courtesy James Lee Cobb III.)

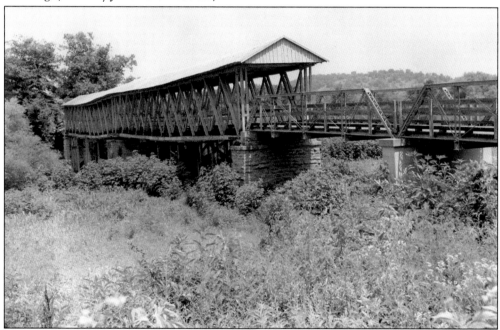

RED LINED SANDERS BRIDGE. On KY 36 over Eagle Creek at the Carroll–Owen County line in the community of Sanders, the bridge was ordered built by the Owen County Court on October 19, 1870, and finished in 1871. Originally a 390-foot, three-span Howe truss, the south span was collapsed by an overloaded truck in 1922 and was replaced by a two-span steel pony truss. The siding was removed from the covered bridge in 1926. On the morning of August 23, 1948, the remaining two covered spans were destroyed by arson.

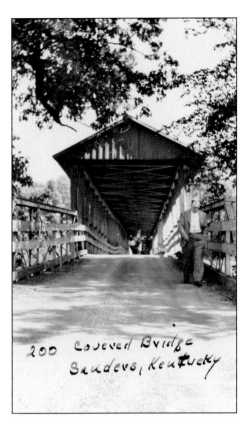

200 Covered Bridge
Sanders, Kentucky

PORTAL VIEW OF SANDERS BRIDGE. Beneath the shade of a nearby tree, the Sanders Bridge was a welcome site for travelers on horseback, in vehicles, or on foot for 77 years. This George Aten photograph was taken shortly before the bridge was lost to arson in 1948.

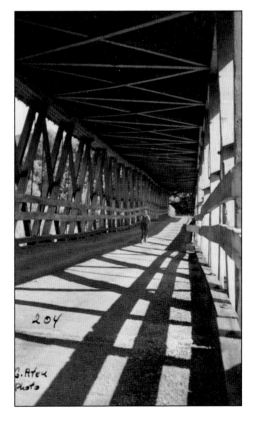

INTERIOR OF SANDERS BRIDGE. Covered bridges housed cool breezes and mysterious shadows that made them irresistible places for children. An interior view of the sagging bridge shows Howe truss construction. This photograph is one in a series of the bridge by photographer George Aten for use in his line of covered bridge postcards.

SPARTA BRIDGE. The covered bridge in Sparta was one of six at or in Gallatin County. The two-span, 250-foot Howe truss was built in 1872 by George A. Wagal on KY 35 over Eagle Creek at the Gallatin–Owen County line. As with many covered bridges in the area, it combined the covered spans with iron pony truss approach spans. The bridge was severely damaged by a fire in March 1935 but continued in use until replaced in 1938.

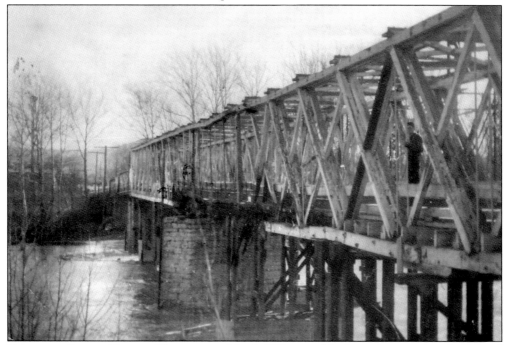

MORIBUND SPARTA BRIDGE. This is a post–March 1935 view of the burned, repaired, and unhoused Howe truss. Several charred timbers are visible. (Courtesy www.nkyviews.com.)

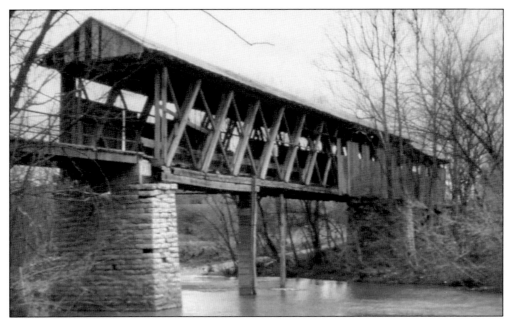

FINAL DAYS AT NATLEE BRIDGE. The 230-foot Natlee Bridge was built in 1871. When the bridge was completed, a celebratory dance was held at a nearby farmhouse. This April 25, 1953, photograph by Traugott F. Keller shows the old bridge just under one year before it was destroyed by arson on March 23, 1954. Keller was born in New York City in 1906 and received his engineering training from the Rensselaer Polytechnic Institute. In 1951, he began traveling the United States photographing covered bridges. Keller died in 1984. (Courtesy NSPCB Archive, Keller Collection.)

NATLEE BRIDGE. A 1946 photograph by Barney Cowherd shows the covered approach span at the west end of Owen County's Natlee Bridge over Eagle Creek on KY 607. This approach span was replaced by steel in 1948. The covered approach spans were unusual on a Kentucky covered bridge, and the 130-foot Howe truss main span was purposefully built slightly taller and wider than the approaches. Due to its deteriorated condition, the appearance is less a covered bridge and more that of a swaybacked mule. (Courtesy the *Courier-Journal*.)

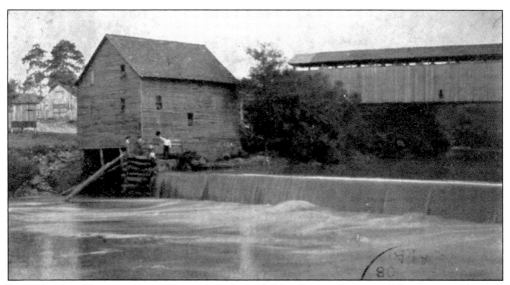

LUSBY'S MILL BRIDGE. Owen County's Lusby's Mill Bridge was built in 1871 at a cost of $8,000. Covered bridges at Natlee, Glencoe, Monterey, and Sanders were ordered built in the same county court directive. The 140-foot, single-span, multiple kingpost bridge with open wood approach spans was built by a Mr. Baker over Eagle Creek on KY 330 and was destroyed by fire October 1, 1926. (Courtesy www.nkyviews.com.)

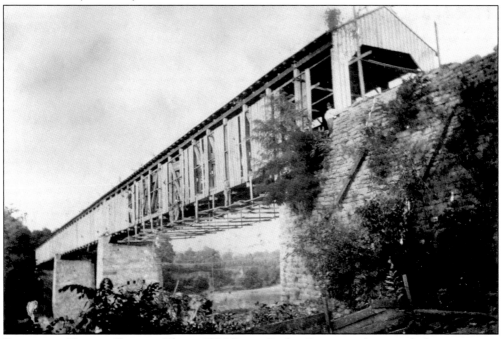

REPAIRS TO BUTLER BRIDGE. This *c.* 1904 Bower Bridge Company photograph shows repair to Kentucky's longest covered bridge. The 456-foot, three-span Burr arch truss on U.S. 27 over the Licking River at Butler in Pendleton County was built in 1870 by J. J. Newman. The bridge was damaged in the 1937 flood, and a new steel bridge was built just upstream. The old bridge was not as weak as originally thought, as it has been reported that it required four cases of dynamite to remove the trusses.

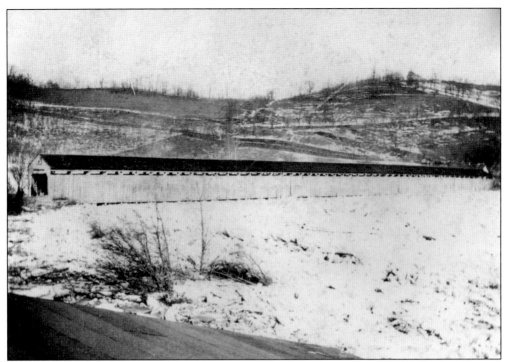

UNYIELDING BRIDGE AT BUTLER. A testament to its builders, the long span withstood the pressure and force of an ice jam in 1918, shown in this Bower Bridge Company photograph.

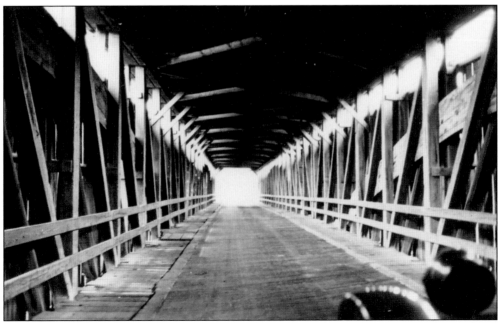

INTERIOR OF BUTLER BRIDGE. This photograph of the interior of the Butler Bridge clearly shows the heavy timbers of the Burr arch truss. (Courtesy Kentucky Historical Society.)

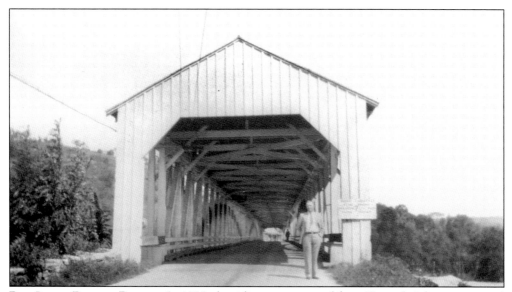

RED LINED BUTLER BRIDGE. In 1926, the siding was removed from Kentucky's longest covered bridge and the trusses painted white.

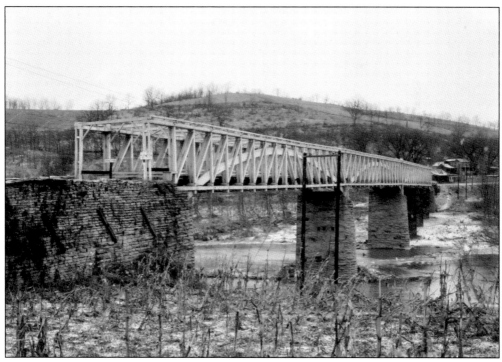

BUTLER BRIDGE. In 1932, the roof and shelter panels were removed from the already unsided bridge. It has been erroneously reported that they were removed in 1937 to reduce the weight of the bridge when it was damaged by the landmark flood. This photograph was taken in 1934 for the Historic American Buildings Survey of the U.S. Department of the Interior.

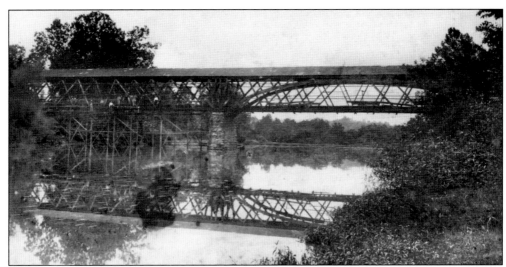

REPAIRS TO MORGAN BRIDGE. A *c.* 1904 Bower Bridge Company photograph shows the covered bridge over the South Licking River at Morgan in Pendleton County. In 1926, the siding was removed from the Morgan Bridge by the Kentucky Highway Department. In 1938, the bridge was condemned and Morgan High School students were forced to exit their school bus and walk across the bridge to the school just on the other side. The Morgan Bridge was replaced by concrete in 1941.

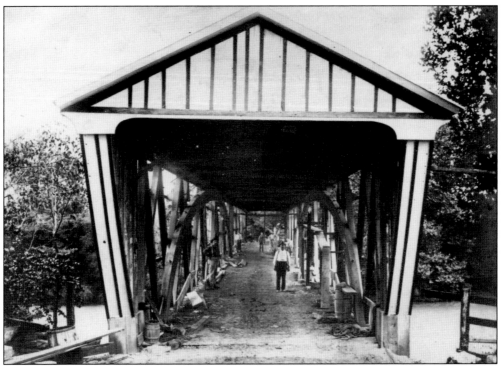

MORGAN BRIDGE. Louis Bower pauses for a moment to pose for the photographer during work on the bridge *c.* 1904. The arches were added at this time; also shown is the green-and-white painted portal that was Louis Bower's signature. Built *c.* 1869, the 270-foot bridge was a two-span Smith Type II truss.

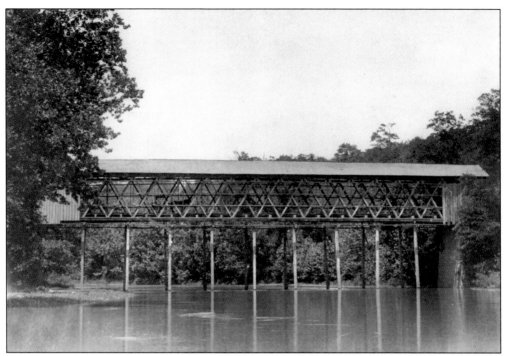

REPAIRS TO PIKE STREET BRIDGE. This 1905 Bower Bridge Company photograph shows repair to the Howe trusses at Falmouth. The bridge was demolished upon completion of the upstream concrete replacement span in 1940. The Bower repair was reported by the *Pendletonian* newspaper as being "an excellent repair."

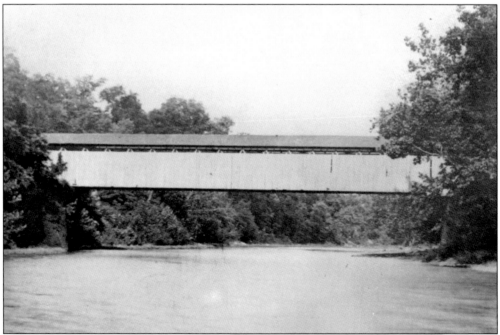

PIKE STREET BRIDGE. The Pike Street Bridge at Falmouth in Pendleton County carried the old 3L Highway over the South Fork of the Licking River. The 170-foot Howe truss was built *c.* 1870.

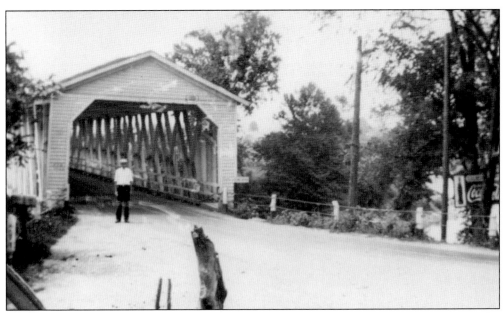

PORTAL VIEW OF PIKE STREET BRIDGE. The siding of the Pike Street Bridge was removed by the Kentucky Highway Department and the trusses painted white in 1926. This view of the north portal was taken in 1939. (Courtesy Miriam Wood.)

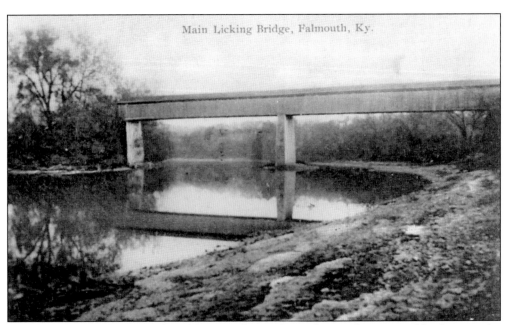

SHOEMAKERTOWN BRIDGE. This old postcard view shows the 308-foot covered bridge over the Licking River between Falmouth and Shoemakertown in Pendleton County. The bridge was built in 1870 to replace a wire suspension bridge that had deteriorated and collapsed. On September 23, 1926, a fire that had been smoldering for several days in a trash pile beneath the bridge flared and ignited the span. Twenty-five minutes from the time that the fire alarm had sounded, the flaming hulk on KY 22 collapsed into the Licking.

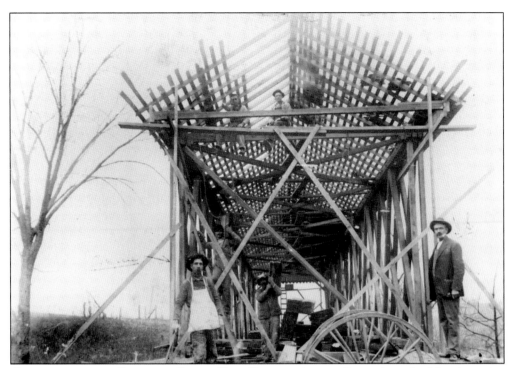

CONSTRUCTION OF STRAIGHT SHOOT PIKE BRIDGE. A rare glimpse into the labor-intensive methods used by bridge craftsmen can be seen in this 1907 photograph taken during the construction of the bridge on Straight Shoot Pike by the Bower Bridge Company.

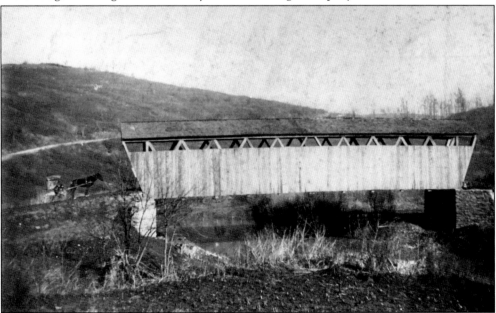

COMPLETED STRAIGHT SHOOT PIKE BRIDGE. The bridge on Straight Shoot Pike over Grassy Creek was the youngest covered bridge in Pendleton County. The Smith Type IV truss stood until 1953, when it was lost to arson. Patsy, the Bowers' black Morgan mare, poses with their buggy just outside the newly completed bridge.

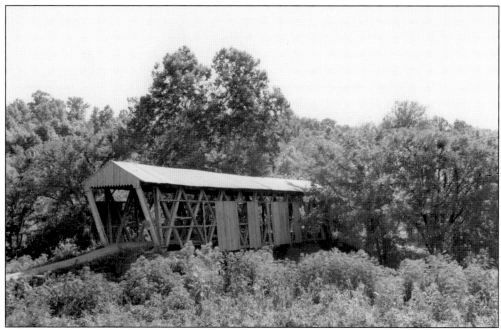

STRAIGHT SHOOT PIKE BRIDGE. This August 4, 1951, photograph was taken near the end of the life of Pendleton County's last covered bridge. (Courtesy Transylvania University Library, John Thierman collection.)

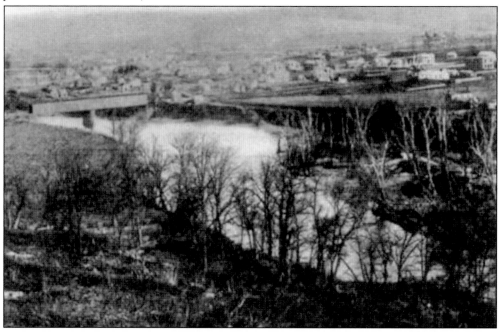

KENTUCKY CENTRAL RAILROAD BRIDGE. The railroad covered bridge at Falmouth is shown in this photograph from the late 1800s. The Shoemakertown Bridge, built in 1870, appears in the distant background. It has been reported that there was an earlier railroad covered bridge at Falmouth that was burned during the Civil War. This railroad covered bridge at Falmouth had been replaced by iron by 1898. (Courtesy www.nkyviews.com.)

Three

KIPDA

Kentucky's largest city and wealthiest county reside in the Kentuckiana Regional Planning and Development Agency (KIPDA) Area Development District. Covered bridges were an integral part of the development of Louisville and of neighboring Oldham County. Travelers once also crossed through the cooling shade of covered bridges in Bullitt, Henry, Shelby, Spencer, and Trimble Counties. (Floyd and Clark Counties in Indiana are also part of the KIPDA ADD.)

Louisville and the surrounding area is home to the Kentucky Derby, the Louisville Slugger, governors, artists, authors, actors, journalists, and athletes. Many contemporary residents of Jefferson County are surprised when they learn that at least 12, and perhaps as many as 19 or more, covered bridges once stood in what is now urban and suburban Louisville. These same Jeffersonians are astounded to discover that at least one covered bridge remained in use in their county until 1915 and that a photograph of it exists. Boy Scouts who for many years held jamborees at Oldham County's Covered Bridge Boy Scout Camp wore a sleeve patch with an image of the old wooden span that once stood adjacent to the camp entrance, and even today this insignia is a desired collectible.

Covered bridges spurred the development of such historically enriched communities as Shelbyville, Taylorsville, Bedford, and Shepherdsville. Even tiny Polsgrove, abandoned practically out of existence by repeated flooding, was once home to a covered bridge. Redevelopment of these areas following the Civil War was quickened by a number of covered bridges using a truss designed by Col. Stephen H. Long when he was stationed in Louisville in the late 1850s. Short, long, wide, and unusual experimental trusses were common over Salt River, Clear Creek, Beargrass Creek, and many other streams from Bedford to Bullitt; they carried horses, wagons, and later the automobiles that would spell their demise on such major highways as KY 36 and KY 55. At least two covered bridges remained on U.S. 60 into the 1920s. The last known covered bridge in the KIPDA ADD was replaced in 1939.

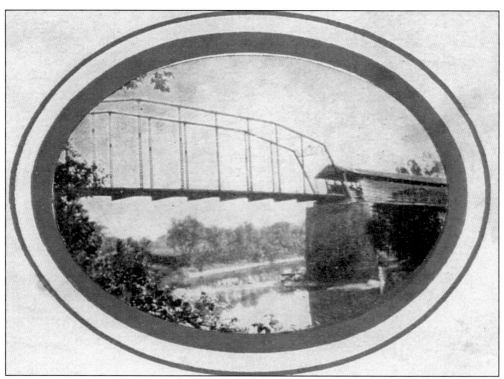

SMITHVILLE BRIDGE. This is a c. 1908 postcard view of the bridge over the Salt River at the Bullitt–Spencer County line on U.S. 31E at Smithville. It is unclear whether the iron truss replaced a second covered span or was added because the river channel was widened by flooding. The entire structure was replaced in the 1920s. The stone abutment for the iron truss and the pier footing continue to exist at the site. (Courtesy Carl Howell.)

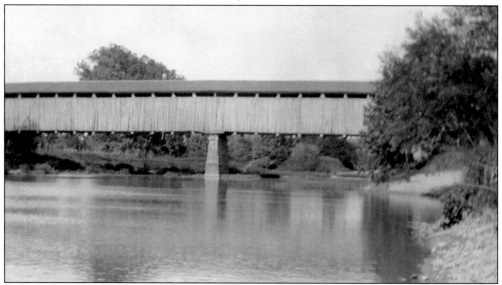

SEATONVILLE BRIDGE. In southern Jefferson County, this 240-foot multiple kingpost truss over Floyd's Fork on Seatonville Road was replaced in 1915. (Courtesy Filson Historical Society, Louisville, Kentucky.)

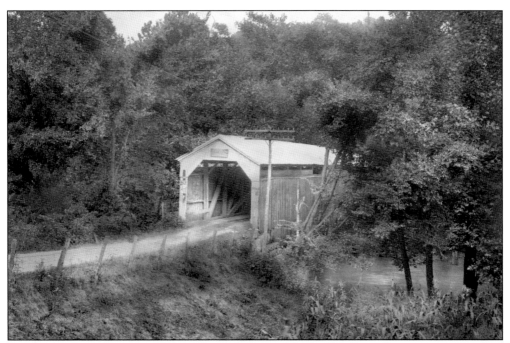

BOY SCOUT CAMP BRIDGE. Oldham County's Covered Bridge Boy Scout Camp was once reached by this bridge over Harrods Creek. This Caufield and Shook view of the bridge on Covered Bridge Road is from 1925. The 120-foot Burr arch truss was accidentally destroyed by a carelessly discarded cigarette. (Courtesy University of Louisville Special Collections.)

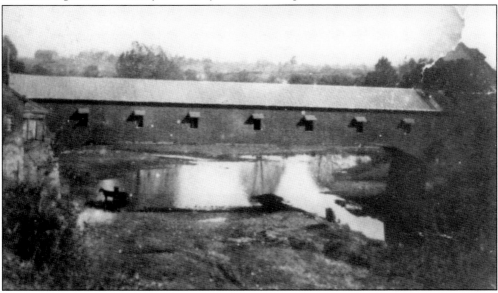

FIRST STREET BRIDGE? This photograph has been identified as having possibly been the bridge on First Street over Clear Creek in Shelbyville. However, the bridge, building perched at one end, and general layout of the creek suggest that it may be a photograph of the Cottontown Bridge in Paris. The louvered windows and overall appearance of the bridge suggest a Wernwag design. If First Street, there is no longer a crossing at this site, as old KY 53 now crosses Clear Creek at Third Street. (Courtesy Jim Cleveland.)

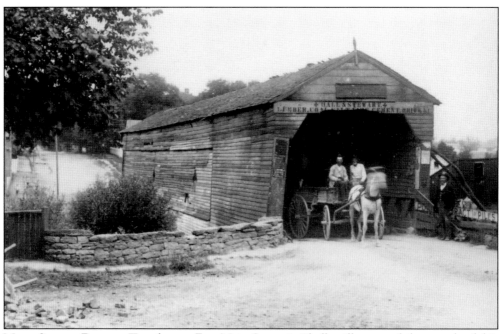

MAIN STREET BRIDGE. Travelers on East Main Street in Shelbyville entered the portals of this Town lattice truss (patented by Ithiel Town in 1820) over Clear Creek for many years. The Hall and Stewart Lumber Yard advertised on the sign attached to the bridge is still in operation. The name is now Hall and Davis. (Courtesy Jim Cleveland.)

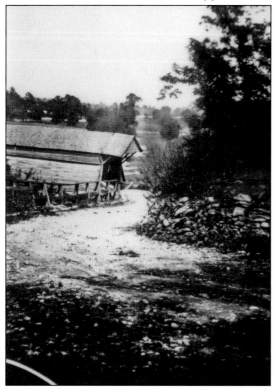

JAIL HILL BRIDGE. This Williams Studio photograph is of the covered bridge over Clear Creek on Jail Hill Road in Shelby County. An iron truss replaced this bridge early in the 20th century. (Courtesy Jim Cleveland.)

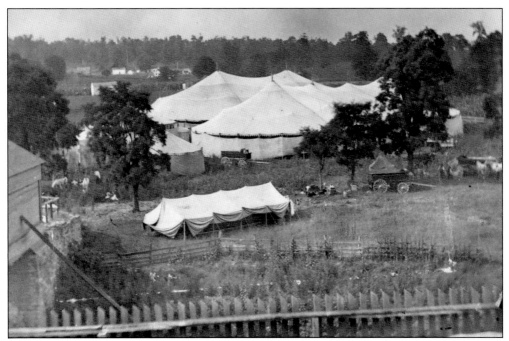

CIRCUS AT JAIL HILL BRIDGE. The areas surrounding covered bridges often were perfect places for gatherings. Here is a vintage view when a circus visited Shelby County. The Jail Hill covered bridge can be partially seen on the left-hand side of the photograph. (Courtesy Jim Cleveland.)

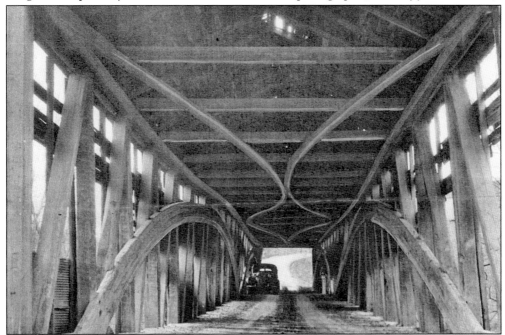

LITTLE MOUNT BRIDGE. This 250-foot, two-span Burr arch truss on KY 1795 over Beech Creek in Spencer County existed until 1939. No information has been discovered other than the existence of the bridge; however, the exterior portal details suggest that it may have been built by Stephen Stone. The auxiliary arches in the overhead truss are unique. (Courtesy NSPCB Archive.)

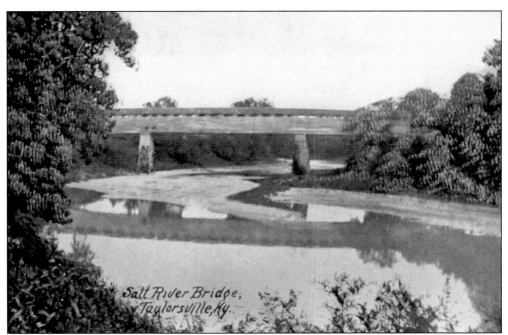

TAYLORSVILLE BRIDGE. This 300-foot modified 1858 patent Long truss carried Main Cross Street over the Salt River at Taylorsville in Spencer County. It was built after the Civil War to replace a burned 1847 covered bridge built by James Carothers at the same location.

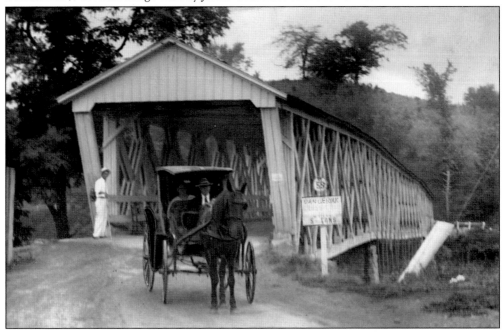

RED LINED TAYLORSVILLE BRIDGE. In 1926, the horizontal siding of the bridge at Taylorsville was removed by the Kentucky Highway Department and the trusses painted. This *Herald Post* photograph shows one of the painters at his task. The covered bridge was demolished when a steel bridge was constructed at a new alignment in 1933. One pier remains at the site today. (Courtesy University of Louisville Special Collections.)

Four

THE LINCOLN TRAIL

For nearly a century, children have played with Lincoln Logs. Since the 1930s, presidential limousines have been manufactured by Lincoln. Illinois is the "Land of Lincoln," but tiny Hodgenville, Kentucky, is the birthplace and childhood stomping grounds of "the Great Emancipator." Numerous courthouse fires have destroyed records that would prove that the 16th president, Abraham Lincoln, could have crossed covered bridges while a child in the commonwealth, but in this area—proud of its presidential heritage—many streams have been crossed by timbered tunnels. Even today, one, now Kentucky's longest, still exists in the Lincoln Trail.

Bardstown is known for bourbon, New Haven for its historic railroad, Bloomfield for basketball, and Boston for its disastrous tornado, but it has been since 1971 that the community of Chaplin and all of Nelson County, among the first in the commonwealth, have been known for a covered bridge.

Covered bridges in the Lincoln Trail were found in all of its eight counties. Numerous streams in Breckenridge, Grayson, Hardin, LaRue, Marion, and Meade, once impassible obstructions, were surmounted with the constructions of the covered bridges that became vital links in the transportation of residents, expansionists, goods, and services. A number of these so-called "sentinels to the days of bustles and buggies, of parlors and pinafores" were significant structures—multiple spans over large streams and double barrels on major trails. A few covered bridges are known to have existed in the state of Texas, and until the 1930s, one remained in use in Texas, Kentucky.

The residents of the Lincoln Trail have always been keenly aware of its history and have fought to preserve their heritage. This awareness was unable to stem the march of time, the forces of progress, arsonists, and institutional apathy; only a solitary structure has remained standing in Washington County and the Lincoln Trail ADD since 1973.

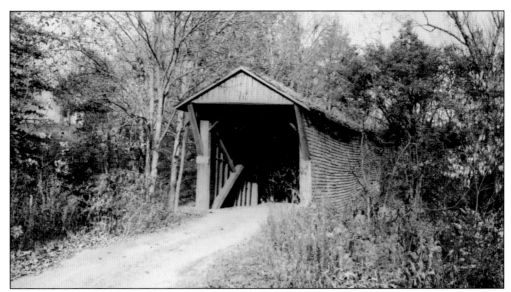

PETER DENT'S BRIDGE. Built in 1847 by the slaves of Peter Dent, this 90-foot, two-span kingpost truss carried Dent's Bridge Road over Sinking Creek in Breckenridge County. The bridge received regular maintenance until about 1940, when the funds were diverted elsewhere. After standing for an even century, one of the lower chords was damaged by a gravel truck because of a continuously leaking roof. (Courtesy Transylvania University Library, John Thierman Collection.)

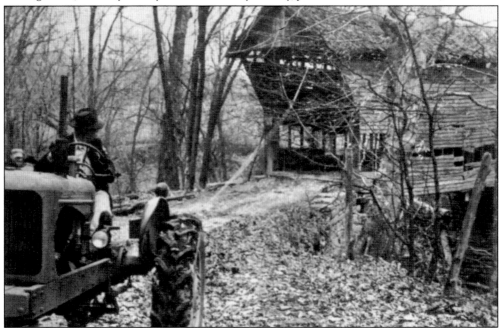

DEMOLITION OF PETER DENT'S BRIDGE. This is a January 30, 1954, photograph of the beginning of the demolition of the then 107-year-old span. The caption from *Covered Bridge Topics* reads: "The work of wrecking the bridge gets underway. Homer Ross and his tractor begin pulling the east end apart. About a fourth of the bridge's sides have been sawed through to speed the job." It has been speculated that repairs a decade earlier would have prevented its deterioration to the point where repair of the hand-hewn timbers was considered too costly. (Courtesy NSPCB Archive.)

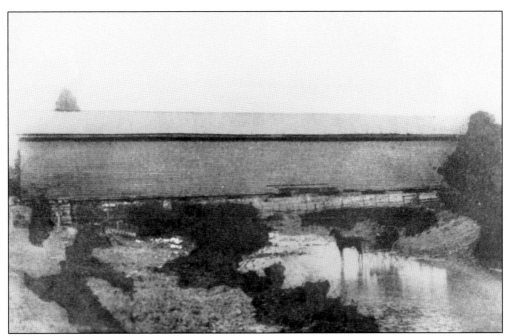

HODGENVILLE BRIDGE. An old postcard view shows the bridge and ford at Hodgenville over the Nolin River in LaRue County. Travelers sometimes preferred crossing through the creek to water their horses and to allow the wooden wheels of their carriages to swell against the iron tires. The 140-foot span was replaced by concrete in 1921.

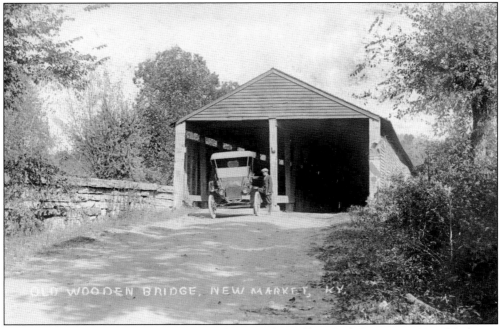

NEW MARKET BRIDGE. The covered bridge over the Rolling Fork River near New Market in Marion County was one of only a handful of Kentucky covered bridges known to have been double barreled. This old bridge was replaced by iron about 1921, and for several years thereafter, a popular local custom was to go out and see the new bridge.

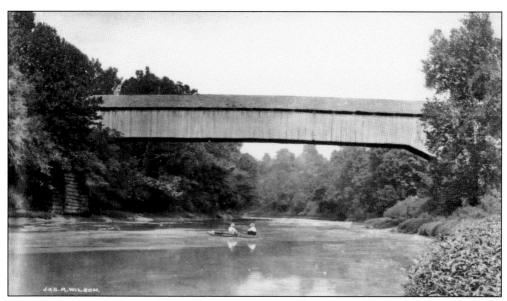

JACKSON HIGHWAY BRIDGE. This 196-foot Burr arch truss was built by William Johnson in 1866 to replace James Carothers's 1832 double-barrel span, which was burned in 1864 during the Civil War. The bridge carried traffic on the Jackson Highway, later U.S. 31E, across Beech Fork in Nelson County until bypassed in 1933. (Courtesy Kentucky Historical Society.)

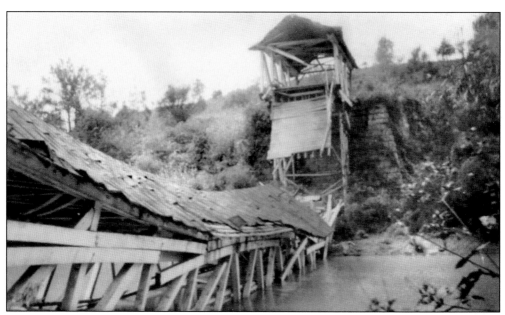

DEATH OF THE JACKSON HIGHWAY BRIDGE. In 1926, the siding was removed from the bridge, exposing the trusses to the elements and leading to its collapse on September 19, 1938.

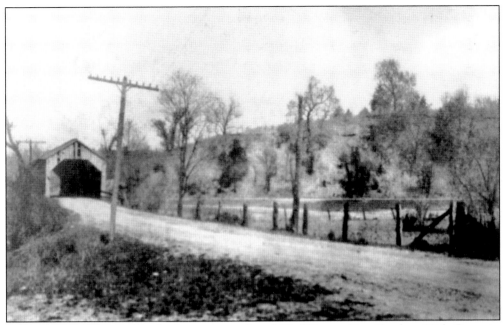

HIGH GROVE BRIDGE. This bridge once stood on U.S. 31E over Cox Creek at High Grove in Nelson County. An early concrete bridge replaced it *c.* 1912.

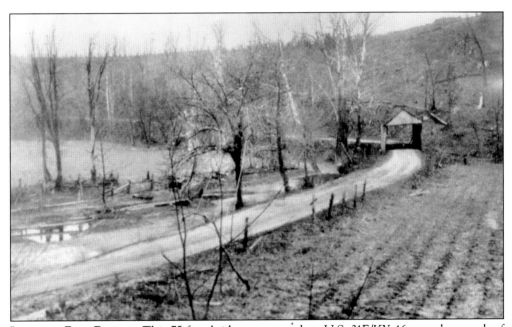

LANDING RUN BRIDGE. This 75-foot bridge once stood on U.S. 31E/KY 46 over the mouth of Landing Run in Nelson County. The road was realigned by the Works Progress Administration (WPA) in 1933, and KY 46 no longer crosses Landing Run. U.S. 31E crosses the stream at a new alignment, and the site of the covered bridge is inaccessible, abandoned, overgrown, and forgotten.

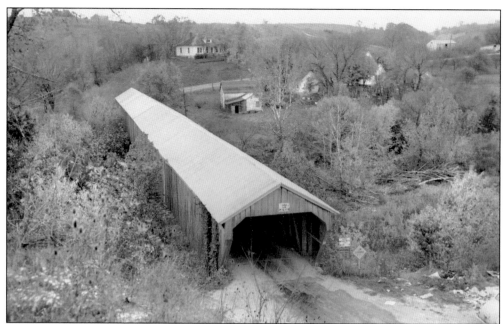

CHAPLIN BRIDGE. This October 21, 1957, view shows the Chaplin or Sutherland Tunnel Mill Bridge at the Nelson–Washington County line over the Chaplin River, which became Kentucky's longest covered bridge when Harrison County's Claysville Bridge was destroyed by fire in 1953. The 270-foot Burr arch truss near Chaplin was built by Cornelius Barnes in 1862 and carried KY 458 until it was closed to traffic by the Kentucky Highway Department on March 11, 1971. (Courtesy Transylvania University Library, John Thierman Collection.)

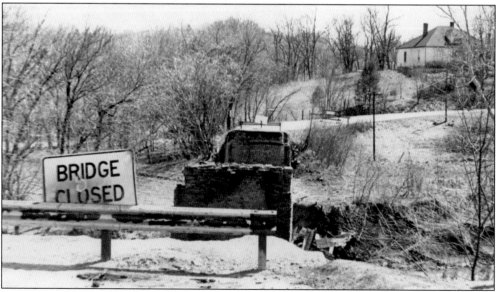

REMAINS OF CHAPLIN BRIDGE. The bridge closure was necessitated by an upstream shift in the center pier, but it inconvenienced travelers on either side of the span, making what had been a 3-mile trip to Chaplin from Washington County 18 miles by another route. At approximately 10:30 p.m. on March 13, 1971, gasoline or another accelerant was poured by persons unknown the length of the 109-year-old span and ignited. This photograph was taken March 15, 1971.

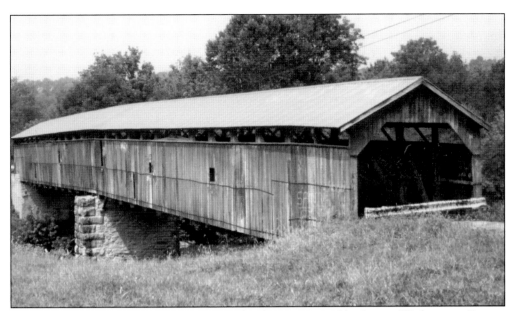

BEECH FORK BRIDGE. The last remaining of 14 known covered bridges in Washington County stands over Beech Fork off KY 458. The 258-foot, two-span Burr arch truss was built in 1865 by Cornelius Barnes and continued to carry traffic until bypassed in 1976. In 1982, local resident Richard Hamilton, a retired building contractor, used his own funds to repair the pier with sandstone that had been quarried in 1895. In this 1996 photograph, the repair to the center pier is visible. (Jurgensen photograph.)

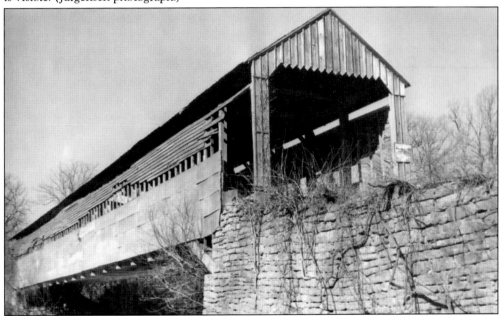

SHARPSVILLE BRIDGE. Built in 1853 by Stephen Stone, the 170-foot Sharpsville Bridge carried KY 53 over the Chaplin River until 1939. At that time, a concrete bridge was built a half mile from the site, and the covered bridge reverted to the ownership of Washington County. Condemned in 1945, it remained open to accommodate residents of Sharpsville but received little maintenance for over 30 years.

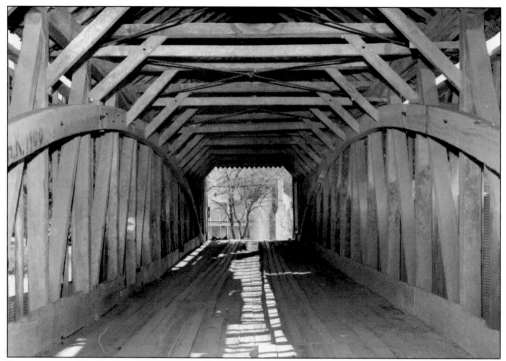

INTERIOR OF SHARPSVILLE BRIDGE. This 1965 photograph shows construction of the Burr arch truss and hand-hewn timbers of the Sharpsville Bridge.

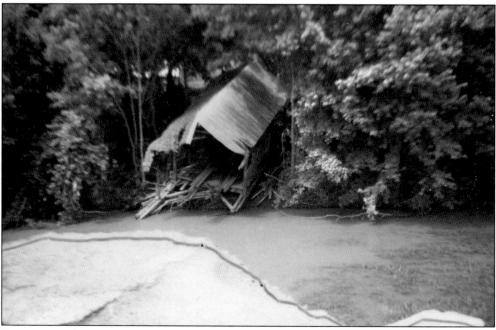

REMAINS OF SHARPSVILLE BRIDGE. On June 21, 1973, after years of neglect, the hand-hewn timbers of the old span collapsed into the river that they had crossed for 120 years. All that remains today of the Sharpsville Bridge is one crumbling and overgrown abutment. (Miriam Woolfolk photograph.)

Five

THE PENNYRILE AND
THE BARREN RIVER

The karst topography of the Pennyroyal Plateau in western Kentucky is bordered to the north by Muldraugh Hill and to the west by the alluvial plains of the Jackson Purchase. The limestone and sandstone escarpments are cut by the tributaries of the Cumberland and Tennessee Rivers. Covered bridges carried early roads over these streams and by default over the underground passages of Mammoth Cave. These caverns form the world's longest cave system, and its length continues to be mapped. Throughout the Pennyrile ADD, as it is officially known, were many timbered tunnels over the Tradewater River, Coefield Creek, and Crooked Creek among others in Caldwell, Christian, Hopkins, Livingston, Lyon, Muhlenberg, and Trigg Counties. None have been discovered to have existed in Todd County. None are believed to have been in the area once known as "Between the Rivers," so called as it was a finger of land between the runs of the Cumberland and the Tennessee. With the formations of Kentucky Lake in the 1940s and Lake Barkley in the 1960s, the pioneer communities of this area, including Golden Pond, Energy, and Fenton, were demolished into memories, their residents forced into relocation. The last Pennyrile covered bridge, in Crittenden County, was demolished in the 1950s.

Corvettes are manufactured in Bowling Green, where the Corvette Museum is found. Western Kentucky University (WKU), Mammoth Cave National Park, and Octagon Hall are among the many other points of interest in the Barren River ADD. In their shadows were numerous covered bridges that provided long walks through their tunnels and picnic spots beneath their timbers. No fewer than 69 covered bridges once carried travelers through Allen, Barren, Butler, Edmonson, Hart, Metcalfe, Monroe, Simpson, and Warren Counties. Two covered bridges remained in use in Logan County in the late 1940s but had disappeared by 1952. With their passing went the legacy of at least 67 others, and the hooded crossings of Biggerstaff Creek and the Mud, Barren, and Gasper Rivers were left as only shadowy, aging photographs and useless, empty abutments dotting the landscape, forgotten reminders of what was.

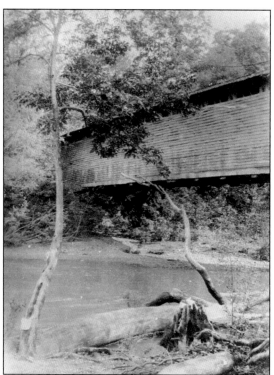

BINN'S MILL BRIDGE. The bridge at Binn's Mill was constructed over the Little River in Christian County in the 1850s by Dutch covered bridge and water mill contractor Daniel Umbenhour. The 164-foot span that carried Binn's Mill Road collapsed without warning in 1933. (Courtesy William T. Turner.)

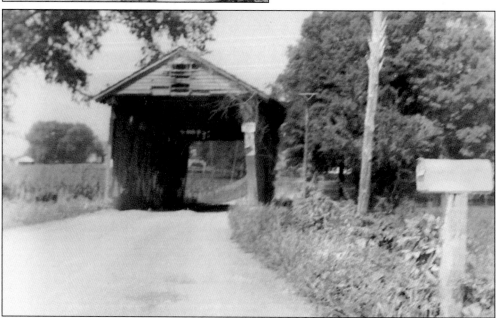

CANTON PIKE BRIDGE. This bridge crossed the North Fork of the Little River on Canton Pike from 1866 to January 31, 1944, when it was replaced by a steel bridge. The 56-foot span utilized a modified 1858 patent Long truss in its construction. It was the last covered bridge in Christian County. A unique process was used when the bridge was replaced: the steel bridge was constructed, slipped inside the covered bridge, and then the old wooden structure was dismantled around it. (Courtesy William T. Turner.)

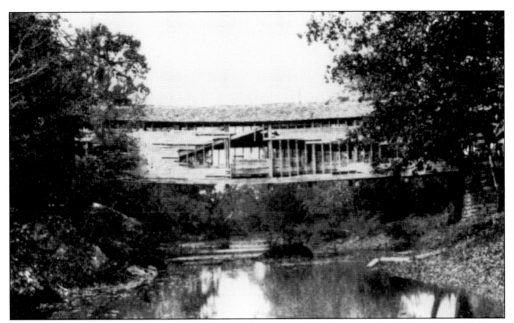

PROWSE BRIDGE. Built in 1880 to replace an earlier covered bridge over which Gen. Simon Bolivar Buckner, CSA, and his men had marched in 1862, the Prowse Bridge over the Pond River on the Johnson Mill Road was a 120-foot McCallum's Arched Inflexible Truss. The McCallum was proven a very sturdy and reliable truss design; however, this bridge at the Christian-Muhlenberg County line had deteriorated significantly in an unusually short, useful life and was replaced by an iron truss in September 1911, a few days after this photograph was taken.

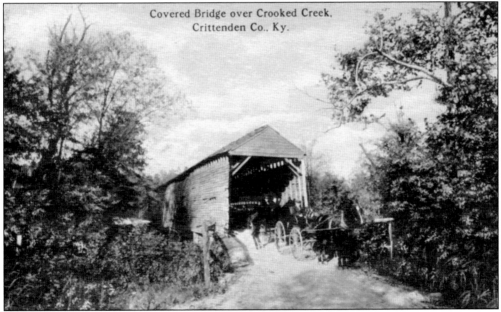

Covered Bridge over Crooked Creek, Crittenden Co., Ky.

CROOKED CREEK BRIDGE. This bridge carried Old Ford's Ferry Road over Crooked Creek in Crittenden County. The 96-foot Burr arch truss was still in use during the 1937 Kentucky Highway Department Map Survey and remained in use for a number of years afterward. According to Marion, Kentucky, historian Ethyl Tucker, the couple in this old postcard view is her parents.

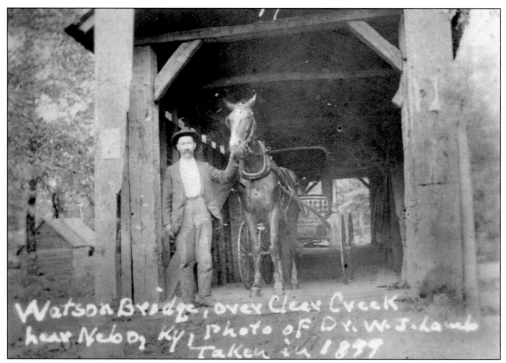

Watson Bridge, over Clear Creek near Nebo, Ky. Photo of Dr. W. J. Lamb. Taken in 1899

WATSON BRIDGE. The Watson Bridge crossed Crooked Creek near Nebo in Hopkins County. The horizontally sided, two-span kingpost bridge was approximately 100 feet long. The man in this 1899 photograph is identified as Dr. W. J. Lamb.

DEER CREEK BRIDGE. This two-span, 75-foot Town lattice truss on Liberty Grove Road over Deer Creek in Livingston County was built by Arch Crosson in 1884. This 1940s drawing by *Louisville Courier-Journal* staff artist Walter H. Kiser is the only known image of the bridge.

PORTAL VIEW OF CADIZ MILL BRIDGE. An old postcard image shows the rarely seen portal. (Courtesy Mary Pat Kroger.)

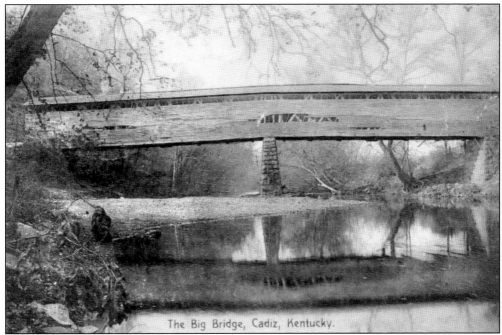

The Big Bridge, Cadiz, Kentucky.

CADIZ MILL BRIDGE. This photograph shows the bridge before the flour mill and dam were constructed. (Courtesy Nina Nunes.)

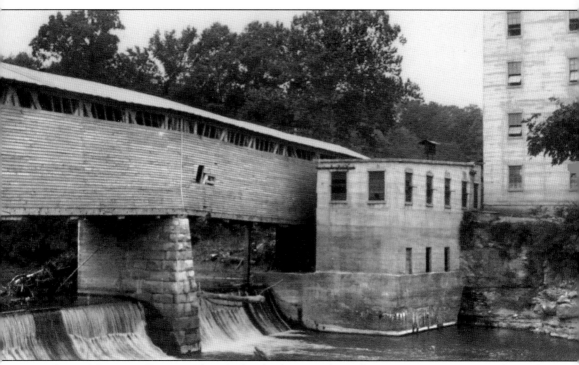

CADIZ MILL AND BRIDGE. The 150-foot bridge at Cadiz Mill in Trigg County crossed the Little River on U.S. 68 until the road was realigned and the bridge removed in 1926. As with many Kentucky covered bridges built after the Civil War, the bridge was constructed with a modified version of Col. Stephen H. Long's 1858 patent truss. The 1858 patent included an inverted wood arch. No Kentucky covered bridge that utilized the inverted arch has been discovered to have existed. (Courtesy Todd Clark.)

KENT'S BRIDGE. This was the last covered bridge to stand in Trigg County. Reportedly haunted by the ghost of a man long ago hanged within its portals, the bridge had its last reported incident of this haunting about 1922.

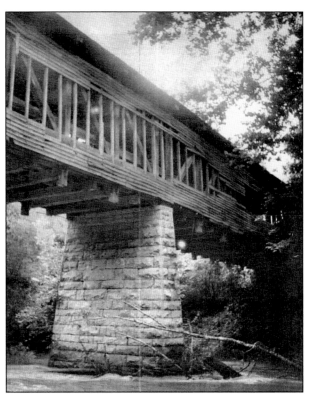

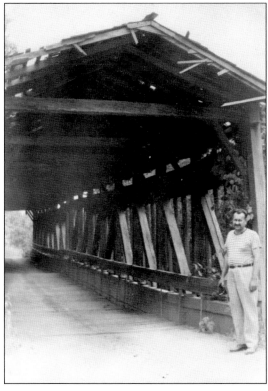

DOOMED KENT'S BRIDGE. Kent's Bridge facilitated travelers on KY 272 for nearly 100 years. The 150-foot multiple kingpost truss over the Little River was built in 1852. Years of neglect and increasingly heavy motor traffic allowed the bridge to deteriorate to such a condition that it would sway when crossed. This photograph was taken in 1950, shortly before it was demolished by the unidentified gentleman standing at the portal.

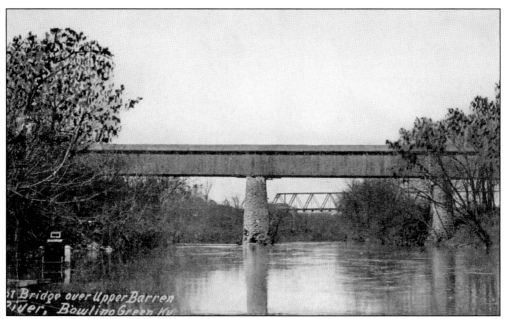

COLLEGE STREET BRIDGE. This long bridge is the second covered bridge to have stood at the foot of College Street over the Barren River at Bowling Green in Warren County since 1819. The bridge was built *c.* 1863 on the piers of its predecessor, which was burned by Confederate troops on February 14, 1862. This bridge burned on February 12, 1915. The iron truss that replaced it still stands on old U.S. 31W on these same piers.

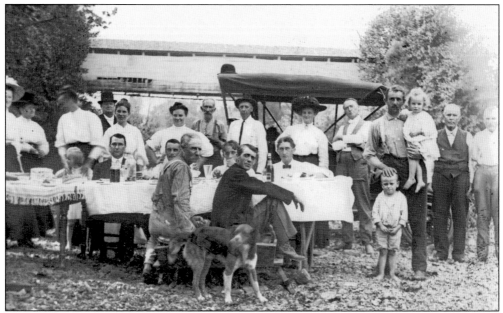

SWEENEY'S MILL BRIDGE. This bridge crossed Drake's Creek on the Old Scottsville Road in Warren County. The back of the photograph reads, "Picture made at covered bridge over Drake's Creek on Old Scottsville Road at Sweeney's Mill about a mile and a half east of Greenwood. A rock dropped through the opening of the bridge at the left hand portion where the planks are torn away would hit on dry land at the edge of the creek." (Courtesy WKU Museum.)

Six

LAKE CUMBERLAND

Lake Cumberland gives name to the Lake Cumberland ADD. The project that created Kentucky's best-known lake began with legislation passed in 1938. Construction of the Wolf Creek Dam began in 1941 and, after a three-year hiatus because of World War II, was completed in 1952. The covered bridges of the Lake Cumberland ADD are believed to have all disappeared by this time, and no evidence has been discovered to suggest that any were removed or inundated by this project. One steel highway bridge at Burnside does remain beneath the lake waters; it and its approach tunnel cut through the limestone ridge at one end make periodic reappearances during times of low water.

The best rendering of a Lake Cumberland ADD covered bridge was publicly unknown for decades. A painting of it graced the Whitehouse home in Lebanon for many years. Recently the family allowed the Tebbs Bend Battlefield Association to restore and sell prints of the old oil painting of the bridge over the Green River in Taylor County that replaced an earlier timbered tunnel burned by John Hunt Morgan and his men. This painting and one photograph that mostly obscures the bridge are the only known images of any of the at least 17 known covered bridges in the counties of the Lake Cumberland ADD, including Clinton, Cumberland, McCreary, and Pulaski. One of Green County's nine covered bridges stood within sight of the Adair County line, but none are known to have stood in Adair. Neither has evidence been discovered of any covered bridges having existed in Casey or Russell Counties. At least one double-barreled covered bridge existed in Wayne County, named for Gen. "Mad" Anthony Wayne; shadow-lines of the three radial arches are evident today on the one existing stone abutment at Zula.

The only known illegal hanging in Green County occurred within the portals of the covered bridge over Big Pittman Creek near Summersville. The old span, believed to have been the last in Green County and in the Lake Cumberland ADD, was replaced in the 1920s.

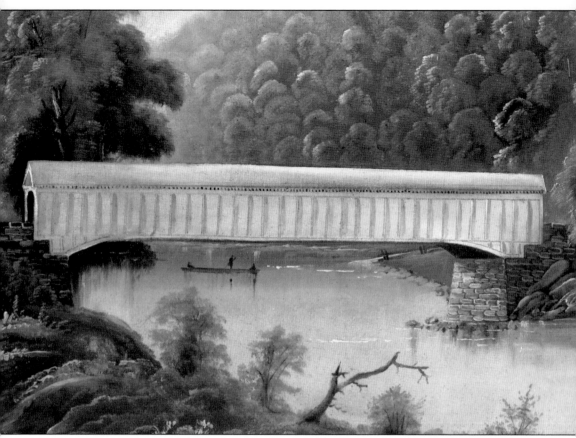

GREEN RIVER BRIDGE. This is the second covered bridge to cross the Green River at this site on Old KY 55 in Taylor County. This bridge was built in 1863 to replace one that was burned during a Confederate raid on January 1, 1863. The plans drawn by Pvt. Edward Henry called for a 160-foot single-span arched truss bridge. Private Henry was also the artist of this painting. Lt. M. A. Hogan and his men constructed the bridge. It stood until, ironically, January 1, 1907, when it was destroyed by a fire of unknown origin. (Courtesy Betty Gorin.)

Seven

THE BLUEGRASS

Kentucky is the Bluegrass State. The horse farms near Lexington continue to produce numerous Derby winners. The first bourbon, University of Kentucky basketball, and, surprisingly, a castle are found in the area known as the Bluegrass Area Development District. Frankfort is the capital of the commonwealth, and with more than 250 of Kentucky's 700-plus former covered bridges having once crossed tributaries and waterways in 17 counties (including Boyle, Clark, Estill, Fayette, Lincoln, Madison, Mercer, and Woodford), the Bluegrass can rightly claim its title as the onetime Covered Bridge Capital of Kentucky.

Perhaps the best-remembered covered bridges of the commonwealth were within the Bluegrass—one in Harrison County *through* which a Civil War battle was fought. Another, over the Kentucky River within sight of the Palisades at the Garrard–Jessamine County line, was for years the longest single-span wooden bridge in the world. Lewis Wernwag, considered the greatest of all the covered bridge builders, left his mark in the Bluegrass, having built a sizeable number of small and large spans within its borders. One stood at Blue Licks in Nicholas County near the site of the last battle of the American Revolution. Another, unrecognized as truly the last Wernwag to exist, stood nearly forgotten, having been moved in the 1920s to dry land and used as a shed on a Bourbon County farm until destroyed in 1968. Historic Bourbon was home to at least 26 timbered tunnels, but only a single example survives.

Franklin County can be called the Capital of the Capital, with a known 38 of these wood spans once dotting the countryside from Graefenburg to Elmville. Now it is home to only the commonwealth's official covered bridge. Scott County was a close second to its western neighbor, having had no fewer than 34 spans crossing Rays Fork, Cane Run, and Lytles Fork among other streams in the valleys surrounding Georgetown.

Travelers through the Bluegrass from Erin's Bridge in Powell County to the Spot in Anderson once heard their footsteps resonate in the shadows of well over 250 of these engineering marvels. Today the echoes whisper in two.

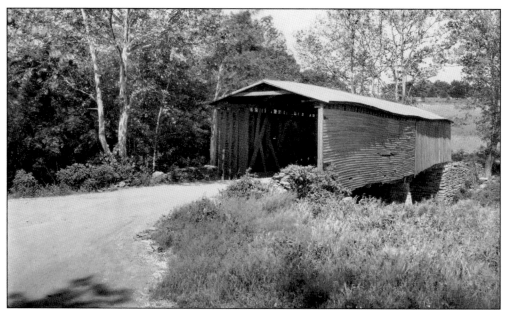

BOND'S MILL BRIDGE. The Bond's Mill Bridge was built in 1847 by Thomas Sellers and Jessie Waterfill over the Salt River at McBrayer in Anderson County. This 130-foot bridge was an unusual combination of kingpost and multiple kingpost trusses with auxiliary compression timbers and interior buttressing. It was bypassed in 1938, sold to Hollie Warford for $100 in 1939, and removed in 1942. The timbers were used to repair and construct several barns in Anderson County. (Courtesy Kentucky Historical Society.)

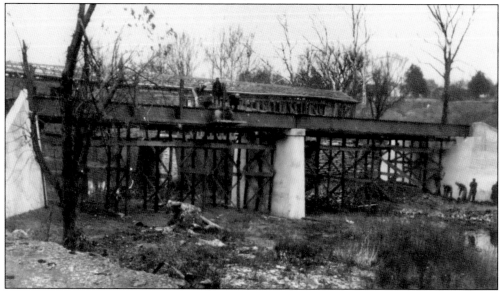

BOND'S MILL BRIDGE. Used by both Union and Confederate troops to cross the Salt River in 1862, the Bond's Mill Bridge survived the Civil War. Originally the Sellers Mill Bridge, the name was changed when the mill was sold in the 1850s. This 1938 photograph shows the covered bridge in the background and its replacement being constructed by the WPA. The stone abutments and ruined pier still exist at the site on KY 513. (Courtesy University of Kentucky Special Collections, George Goodman Collection.)

GLENSBORO BRIDGE. The covered bridge at Glensboro is right at home in this picturesque setting. The *c.* 1900 photograph shows the bridge built by Stephen Stone over the Salt River at the community of Glensboro—also known as Camden—in 1855 or 1856 in Anderson County. By 1923, the 170-foot Burr arch truss on KY 53 had been condemned; it was replaced by an iron truss some years later. (Courtesy Jim Cleveland.)

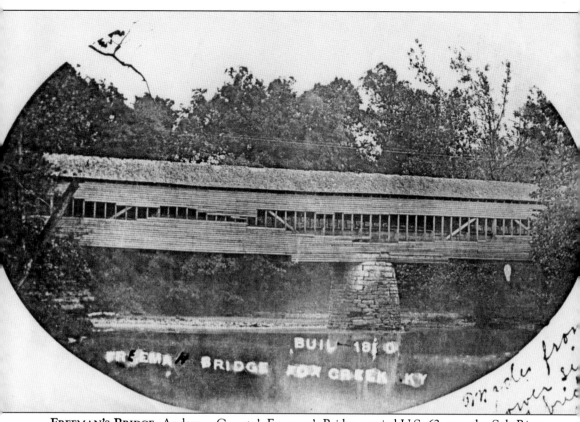

FREEMAN'S BRIDGE. Anderson County's Freeman's Bridge carried U.S. 62 over the Salt River near the community of Fox Creek. Built in 1810 by Ludwig Cornish and George Freeman, the 200-foot, two-span queenpost truss had deteriorated by the 1920s and was replaced by concrete in 1931. (Courtesy L. K. Patton.)

VAN BUREN BRIDGE. The only known photograph of the 100-foot covered bridge over Clear Creek on KY 1579 at the Anderson County community of Van Buren, named for the eighth president, appeared in the *Anderson News* in 1906. The bridge was destroyed in 1912 by a fire that consumed the residence to its right. The site, including that of the entire community of Van Buren, is now under Taylorsville Lake. (Courtesy Dr. Jerry Phelps.)

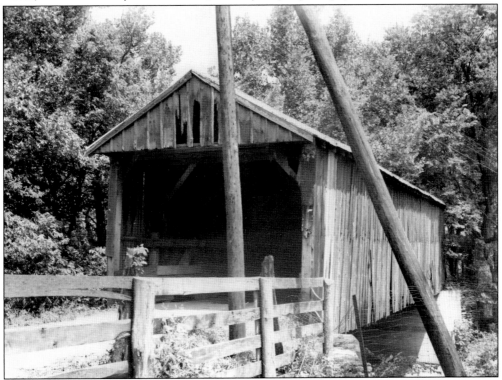

FORD'S MILL ROAD BRIDGE. Over Houston Creek on Ford's Mill Road in Bourbon County, this 90-foot multiple kingpost truss was a conservatively built span, as the trusses did not extend the full height of the bridge. This July 3, 1943, J. Winston Coleman photograph was taken eight years before the bridge was replaced by concrete. The encased abutments are still in use.

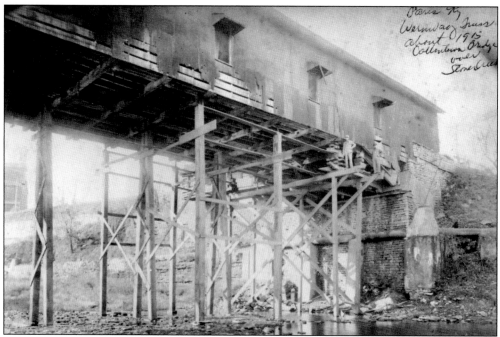

REPAIRS TO COTTONTOWN BRIDGE. The Cottontown Bridge stood for 100 years over Stoner Creek on U.S. 68 at Paris in Bourbon County. Built by Lewis Wernwag, the 160-foot double-barrel Wernwag truss, shown during the 1915 Bower Bridge Company repair, was replaced in 1933. At the time this photograph was taken, corrugated sheet metal had replaced the original vertical siding on the north side of the bridge. Some years prior, the siding had been removed from the south side and a pedestrian walkway added.

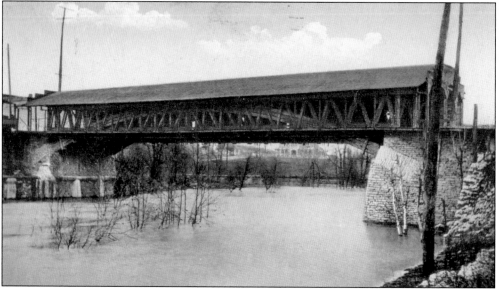

COTTONTOWN BRIDGE. It has been reported that when the bridge was replaced in 1933, the timbers were numbered for future reconstruction and stored in a nearby warehouse. It has also been reported that in the 1940s, these timbers were removed. Their current whereabouts remain unknown.

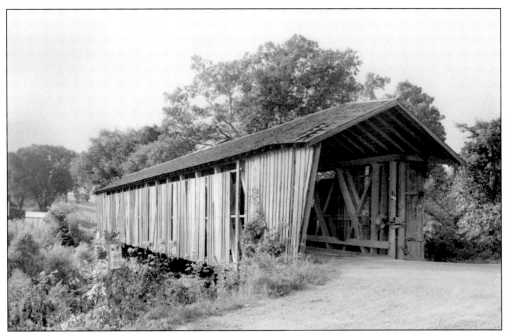

JACKSTOWN BRIDGE. Built in 1877 by Tom Ford and Henry Johnson over Hinkston Creek on KY 13 at the Bourbon–Nicholas County line, the Jackstown Bridge was the last covered bridge demolished by the Kentucky Highway Department. This 1944 J. Winston Coleman photograph shows the 144-foot Howe truss prior to the removal of the shelter panel at the Nicholas County end.

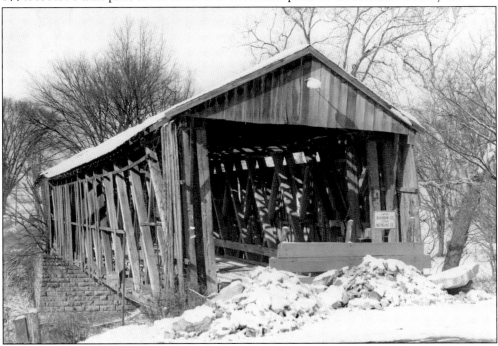

FINAL MINUTES AT THE JACKSTOWN BRIDGE. In 1960, a heavily laden truck severely damaged the lower chords of the Jackstown Bridge, as evidenced in this January 21, 1961, photograph. Demolition of the 84-year-old span began immediately after this photograph was taken.

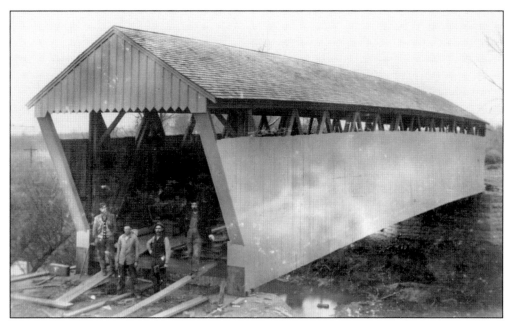

MILLERSBURG BRIDGE. This c. 1900 view was made during the construction of the second covered bridge over Hinkston Creek at Millersburg in Bourbon County. The first Millersburg Bridge was built by Lewis Wernwag and survived the Civil War. This 120-foot, Smith Type IV truss was built by the Bower Bridge Company. For unknown reasons, an iron truss replaced this bridge in 1905. The abutments still exist at the site.

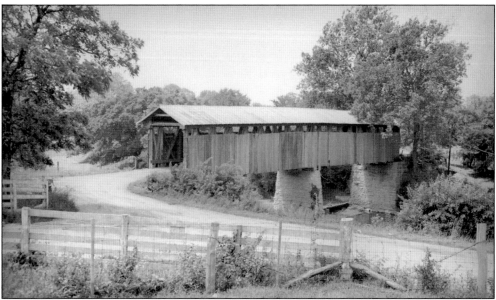

RUDDLES MILL BRIDGE. The 150-foot, two-span Ruddles Mill Bridge stood over Stoner Creek on Shawhan–Ruddles Mill Road in Bourbon County and was constructed in 1861. This photograph was taken on June 17, 1947. This beautiful scene was forever lost on August 11, 1964, when the bridge was destroyed by arson. Just five days before the bridge was burned, the Bourbon Fiscal Court had allocated $8,000 for repairs and had contacted Stock Bower to perform the work. (Courtesy Transylvania University Library, John Thierman Collection.)

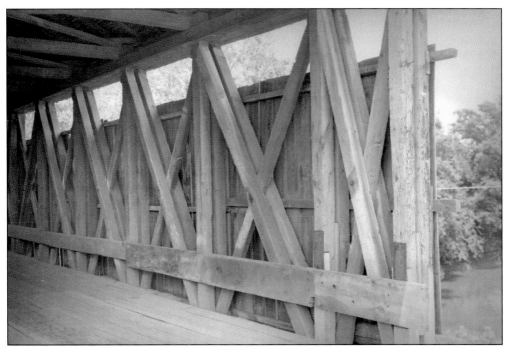

INTERIOR OF RUDDLES MILL BRIDGE. A June 17, 1947, photograph of the bridge interior shows the Long truss, constructed from the original 1830 patent design. (Courtesy Transylvania University Library, John Thierman Collection.)

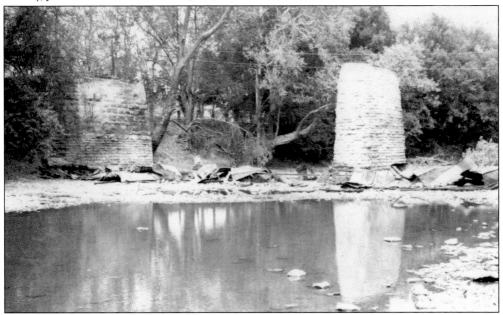

REMAINS OF RUDDLES MILL BRIDGE. Minutes before the bridge burned, area residents said they saw a light-colored car with three teenagers traveling toward the bridge. Fire companies from all over the county, including some off-duty firemen, responded. In such a hurry to try to save the bridge, they lost control of their fire truck, ran off the road, and had to be hospitalized. (Courtesy L. K. Patton.)

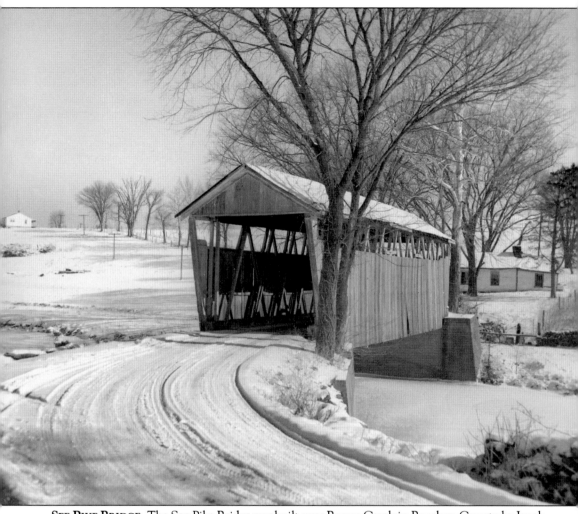

SEE PIKE BRIDGE. The See Pike Bridge was built over Boone Creek in Bourbon County by Jacob Bower in 1874. At the time of its replacement in 1967, there was talk of re-erecting the 60-foot, Smith Type IV truss in Cherokee Park in Louisville. The timbers were instead cut into short lengths and deposited in the nearby abandoned rock quarry that had provided the stone for the abutments 93 years earlier. (Courtesy Transylvania University Library, John Thierman Collection.)

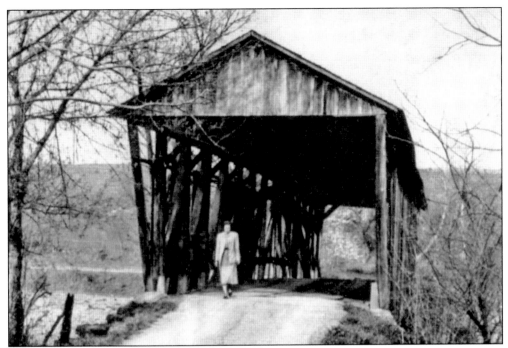

PORTAL VIEW OF SAM BOOTH BRIDGE. This view shows the arches that were added by the Bower Bridge Company in 1912. Although unconfirmed, a persistent rumor is that the long-neglected bridge collapsed in 1951 just after a drove of cattle passed through. (Courtesy NSPCB Archive.)

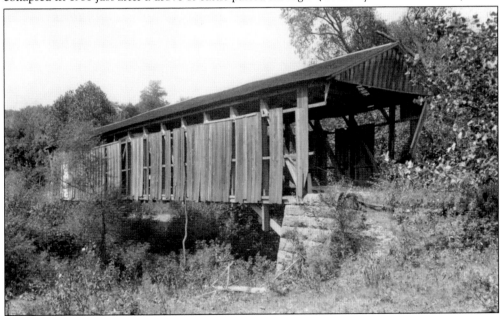

SAM BOOTH BRIDGE. The Sam Booth Bridge crossed Hinkston Creek on Convict Road at the Bourbon–Nicholas County line until it was replaced by a concrete bridge in 1951. The 110-foot multiple kingpost truss was repaired by the Bower Bridge Company in 1912. To strengthen the bridge, the Bowers added arches to the trusses. This J. Winston Coleman photograph was taken September 8, 1945.

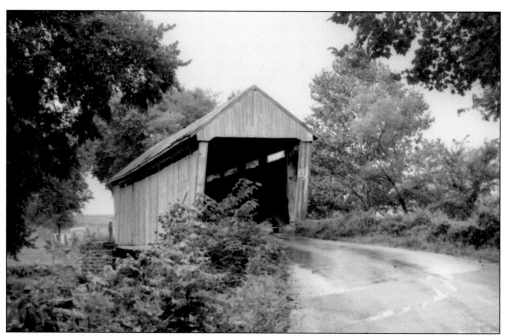

STRODES CREEK BRIDGE, KY 956. This 1953 photograph is by Lynn Vaughn. This photograph was mislabeled in 1965 as the Green Creek Bridge, also in Bourbon County, and the error has followed this image for 40 years. The Green Creek Bridge on U.S. 227 was a horizontally sided queenpost truss and was replaced in 1940.

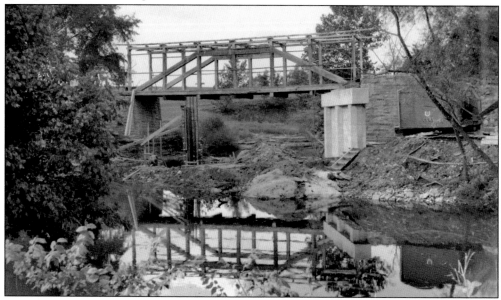

DEMOLITION OF STRODES CREEK BRIDGE, KY 956. A September 1956 photograph of the bridge was taken at the end of 124 years over Strodes. This was one of four covered bridges on the Clintonville–North Middletown Road in Bourbon County built in 1832 by Lewis Wernwag. Built of queenpost trusses, three of the four, including this 60-foot span over Strodes Creek, remained in use for 124 years. All three were replaced in 1956. (Courtesy Transylvania University Library, John Thierman Collection.)

STRODES CREEK BRIDGE, U.S. 227. Here is one of four covered bridges built by Lewis Wernwag on the Paris-Winchester Pike in 1831. Three of these bridges, including this 40-foot queenpost truss over Strodes Creek, served traffic until 1940. Special housings at the chord ends of each of these bridges allowed them to remain in excellent condition until their replacement.

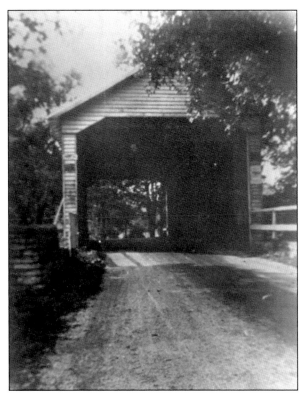

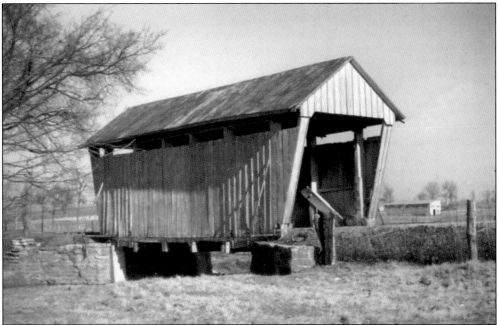

PRETTY RUN BRIDGE. This view of Lewis Wernwag's Pretty Run Bridge in Bourbon County was taken on March 7, 1953, by Traugott F. Keller Jr. Pretty Run was the middle and shortest of the three queenpost bridges on KY 956 in Bourbon County that survived into the 1950s. A concrete culvert replaced the 40-foot bridge in 1956. (Courtesy NSPCB Archive, Keller Collection.)

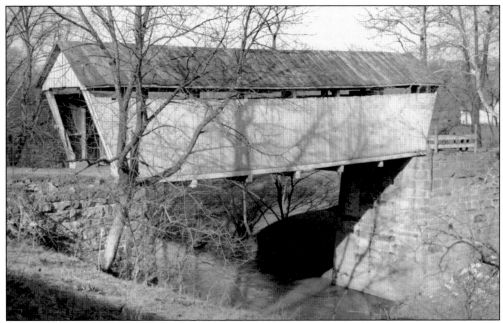

THATCHERS MILL BRIDGE. Over Stoner Creek on KY 956, this 60-foot queenpost twin of the Strodes Creek Bridge on the same road also was replaced by a concrete bridge in 1956. (Courtesy Transylvania University Library, John Thierman Collection.)

WRIGHT'S MILL BRIDGE. Built by Lewis Wernwag in 1832 on U.S. 68 over Houston Creek in Bourbon County, this bridge was removed to the farm of Julia Breckenridge Ardery in 1926. A windstorm destroyed it in 1968. This 1965 photograph shows Mrs. Ardery and KCBA cofounder Paul Atkinson. Although a bridge argued to be a Wernwag truss currently exists in Ohio, it was built after the master builder had died. Although not formally recognized as such, the Wright's Mill Bridge was the last Wernwag-built bridge to exist. (L. K. Patton photograph.)

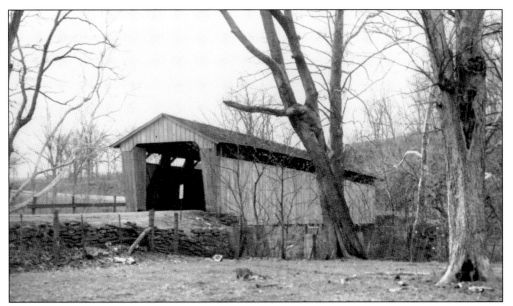

COLVILLE BRIDGE. This bridge, built by Jacob Bower, has crossed Hinkston Creek on Colville Road in Bourbon County since 1877. The 120-foot multiple kingpost structure continues to carry traffic to this day. Repaired by Louis Bower in 1913, the bridge was strengthened and raised to its present height by Stock Bower in 1937. It is one of two remaining Kentucky covered bridges built by the Bower Bridge Company.

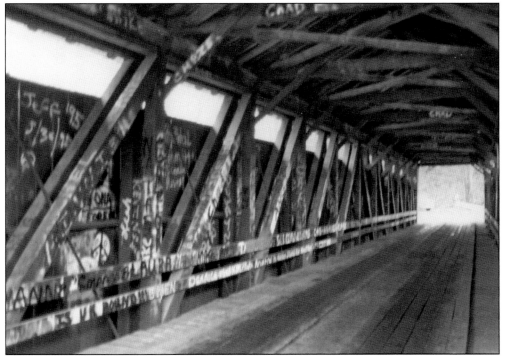

INTERIOR OF COLVILLE BRIDGE. Over the years, the bridge was the target of attacks by vandals. This photograph from 1997 shows the heavy coating of graffiti on the trusses. (Jurgensen photograph.)

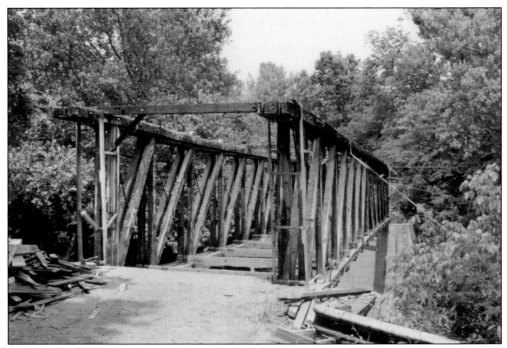

REPAIRS TO COLVILLE BRIDGE. In March 1997, the bridge was pushed slightly off its abutments in a severe flood and was subsequently closed to traffic. Restoration began in 2000. This view is as it was being dismantled for restoration. (Jurgensen photograph.)

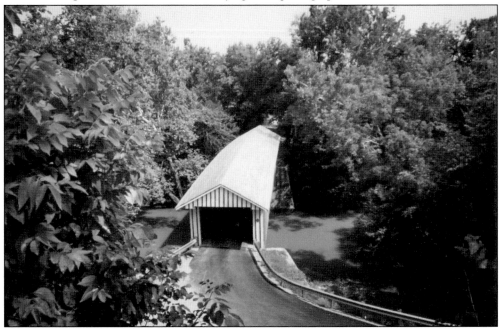

RESTORED COLVILLE BRIDGE. Construction was completed in April 2001, and the newly restored bridge once again spans Hinkston Creek. The restoration of the bridge brought back some original features that were lost over time: the camber, cedar shingles, and the Bower Bridge Company's signature white-and-green portals. (Jurgensen photograph.)

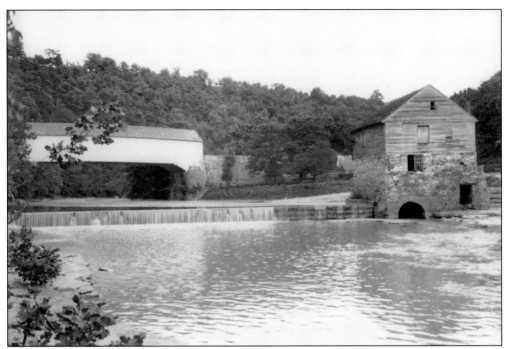

KING'S MILL AND BRIDGE. This June 1, 1913, view shows the mill and bridge over the Dix River at the Boyle–Garrard County line. Built on KY 34 in 1836 by Lewis Wernwag, this 170-foot, double-barrel Wernwag truss was removed in 1926.

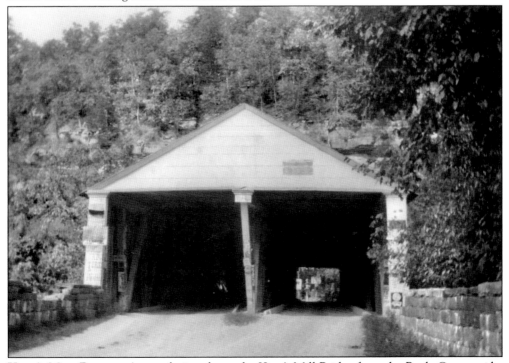

KING'S MILL BRIDGE. A portal view shows the King's Mill Bridge from the Boyle County side. (Courtesy Filson Historical Society, Louisville, Kentucky.)

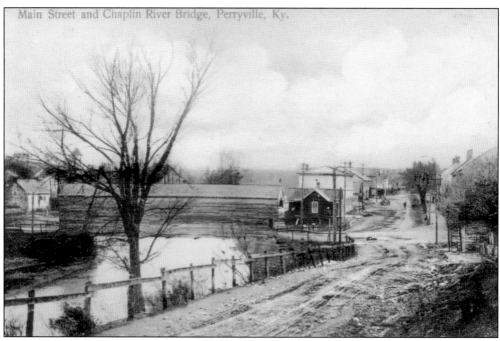

PERRYVILLE BRIDGE. The bridge at Perryville in Boyle County crossed the Chaplin River on KY 52 until it was removed in 1909. On September 14 of that year, the bridge was irreparably damaged by a traction engine with a 20 ton rock crusher attempting to cross. It was permanently closed to traffice and soon thereafter replaced by an iron truss. (Courtesy Todd Clark.)

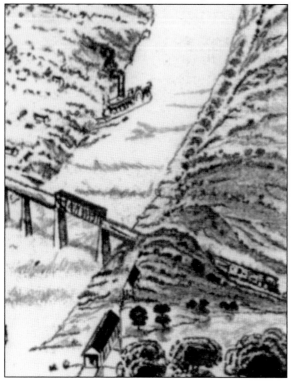

BELLEPOINT BRIDGE. For many years, the only known image of this 140-foot bridge over the mouth of Benson Creek at Frankfort in Franklin County appeared on an 1871 bird's-eye view map of Kentucky's capital. Recently, a photograph of the bridge and surrounding area was discovered hidden behind another framed picture in a Versailles antique store. The bridge was built in 1870 to carry what would become U.S. 421 and was replaced by a now bypassed and recently restored iron Whipple truss prior in 1881. The original iron replacement span was under construction in 1880 when it collapsed on December 6. The iron Fink truss railroad bridge over the Kentucky River also appears in this drawing. Frankfort High School's Panthers have played football on Sower Field, within sight of this location, since the 1920s.

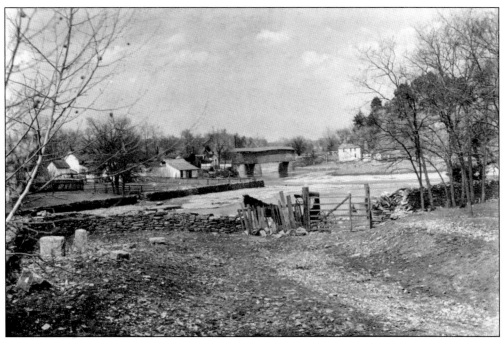

FORKS OF ELKHORN AND BRIDGE. On the Georgetown Road at the Forks of Elkhorn over South Elkhorn Creek in Franklin County, this 120-foot, two-span McCallum's Arched Inflexible Truss was built in 1867. A similar bridge just to the north on Schoolhouse Road over the North Fork of Elkhorn Creek burned c. 1900. This view by E. C. Wolff from the 1890s shows the Georgetown Road covered bridge with its original horizontal siding. (Courtesy Kentucky Historical Society.)

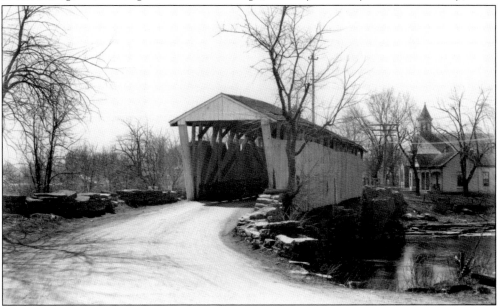

FORKS OF ELKHORN BRIDGE. In 1920, the bridge was repaired by the Bower Bridge Company. The horizontal siding was replaced with vertical and the shelter panels angled at that time. This 1926 Harry Gretter photograph shows the old bridge after this reconstruction. (Courtesy Kentucky Historical Society.)

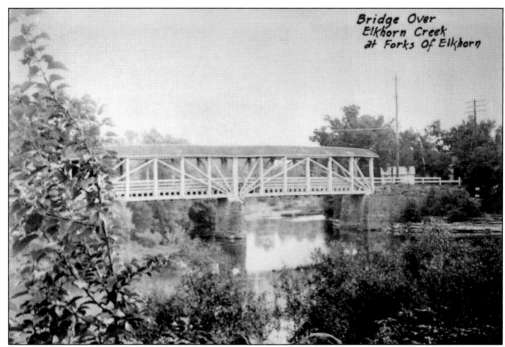

Bridge Over Elkhorn Creek at Forks Of Elkhorn

RED LINED FORKS OF ELKHORN BRIDGE. In 1926, the siding was removed from the 59-year-old span, exposing the newly painted McCallum trusses to the elements. The bridge quickly deteriorated and was replaced by concrete in 1936. (Courtesy Kentucky Historical Society.)

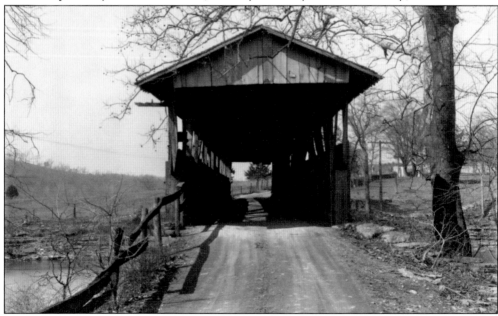

KNIGHT'S BRIDGE. This 1926 portal view is by Harry Gretter. Built in 1863 by John Gault, this 200-foot, two-span McCallum's Arched Inflexible Truss carried Peaks Mill Road over Elkhorn Creek in Franklin County. A popular watercolor of this bridge was painted in the 1890s by Frankfort artist Paul Sawyier (1865–1917). More than one watercolor of Sawyier's depicted this bridge. Knight's Bridge was replaced in 1935 by a steel pony truss. (Courtesy Kentucky Historical Society.)

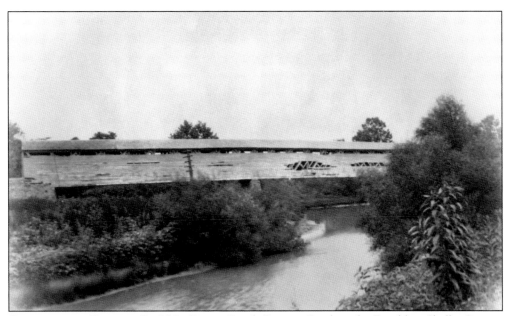

GRAEFENBURG BRIDGE. On U.S. 60 over South Benson Creek at the Franklin–Shelby County line, this 1920 view, generally credited to Willard Rouse Jillson, shows the two-span, 190-foot bridge before the horizontal siding was removed by the Kentucky Highway Department in 1926. (Courtesy NSPCB Archive.)

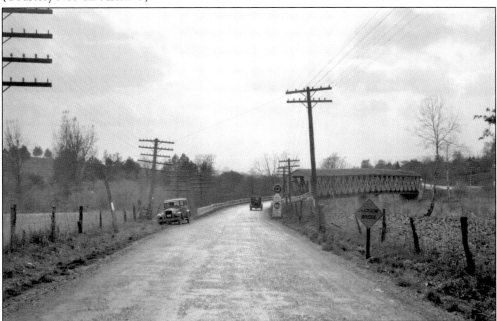

RED LINED GRAEFENBURG BRIDGE. A July 2, 1930, photograph by R. G. Potter shows the Graefenburg Bridge after the siding had been removed, the portals redesigned, and the trusses painted, exposing the modified 1858 patent Long truss to the elements. The sign to the right advertises "That Good Gulf Gasoline." The Graefenburg Bridge was the first Kentucky covered bridge to be demolished after receiving this Red Line treatment. The 64-year-old bridge was replaced by concrete in 1930–1931. (Courtesy University of Louisville Special Collections.)

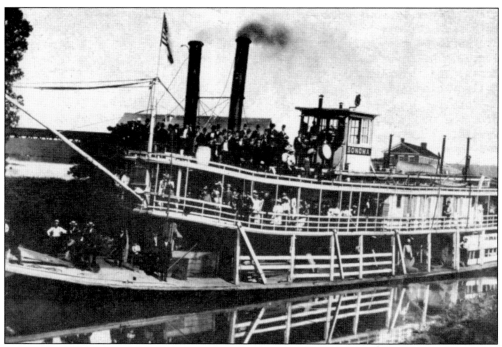

POLSGROVE BRIDGE. This Smith Type IV truss over Flat Creek on KY 12 at the Franklin–Henry County line appears in the background of a photograph of the riverboat *Sonoma* taken prior to 1913 at the Mayflower Hotel Landing at Swallowfield.

ST. CLAIR STREET BRIDGE. This view is from the site of the covered bridge over Devil's Hollow on Taylor Avenue in Frankfort. The Devil's Hollow covered bridge had been replaced by the iron pony truss just visible on the right of the photograph by the time this image was made in the 1880s. (Courtesy Kentucky Historical Society.)

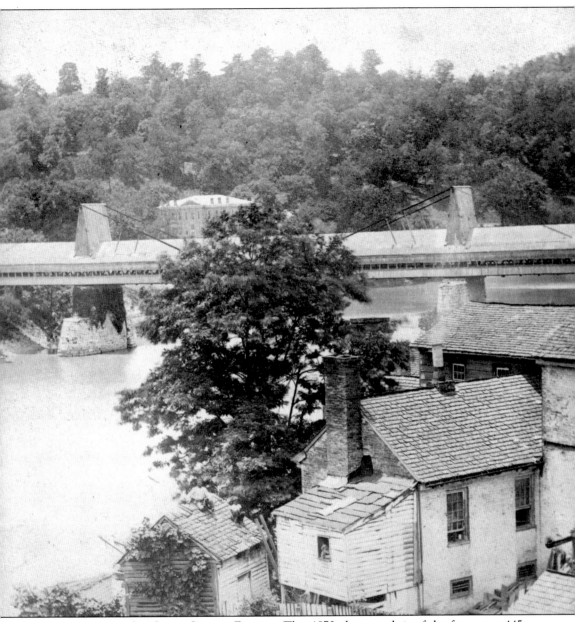

Unique View of St. Clair Street Bridge. This 1870 photograph is of the four-span, 445-foot Howe truss over the Kentucky River at Frankfort. This image is one half of a stereoview and is significant for several reasons. It is the only known stereoview specifically of the bridge. It is the earliest of only a few original prints of the bridge to still exist. It is the earliest known photograph of the bridge, and it is the only known photograph showing the suspension towers. It is also one of the earliest known original print of any Kentucky covered bridge. It has been speculated that the towers were added after 1862 to repair the damage done to the bridge as a result of the Confederate occupation of Frankfort. The towers had been removed by 1883. The earliest known image of the bridge is a highly detailed 1860 watercolor of Frankfort by S. I. M. Major painted before the towers were installed. The large brick structure in the background is the original Frankfort High School building, built in 1868.

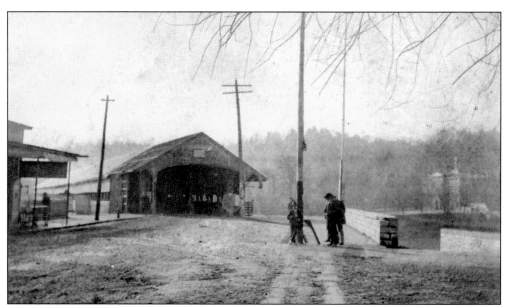

Portal View of St. Clair Street Bridge. Even after the 50-year-old bridge was removed in 1894, it often appeared in artwork by Paul Sawyier. This photograph was taken by Sawyier. The St. Clair Street Bridge is the only Kentucky covered bridge known to have been originally built with sidewalks. The wooden truss of the covered bridge was left in place as scaffolding during construction of the present Singing Bridge. (Courtesy Kentucky Historical Society.)

Louisville and Nashville Railroad Bridge. The first railroad covered bridge at Frankfort was built in 1850 over the Kentucky River and was burned by the Raiders of Gen. John Hunt Morgan in 1862. This postcard view of Lock 4 shows the second railroad covered bridge in the background. The 350-foot, two-span bridge was built in 1864 and lost in a flood in 1868. A well-remembered iron Fink truss was constructed on the site that same year. (Courtesy Kentucky Historical Society.)

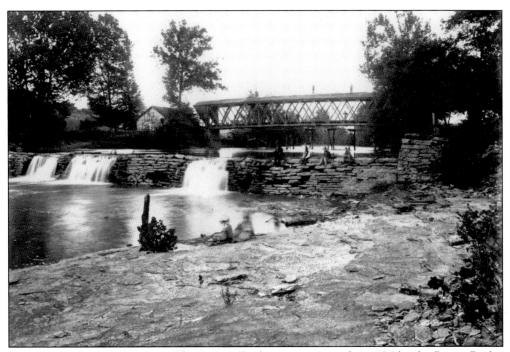

REPAIRS TO SWITZER BRIDGE. The Switzer Bridge was renovated in 1906 by the Bower Bridge Company. In the foreground is the dam that provided power to the Jones Brothers mill. Remnants of the dam still exist today. (Courtesy Kentucky Historical Society.)

REPLACEMENT OF SWITZER BRIDGE. Built in 1855 by George Hockensmith, the 120-foot Howe truss crosses the North Fork of Elkhorn Creek in Franklin County. The bridge has been on the brink of death throughout its history but has managed to always survive. This view of the then-98-year-old span shows the construction of the concrete Harrold Cunningham Memorial Bridge in 1953. Cunningham was the local magistrate responsible for preventing the destruction of the covered bridge when it was bypassed. (Courtesy Transylvania University Library, John Thierman Collection.)

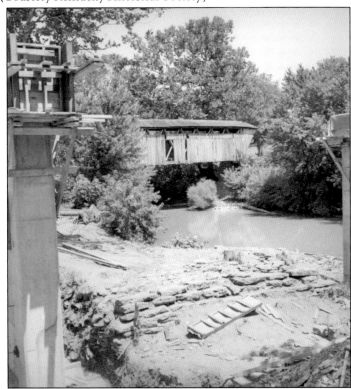

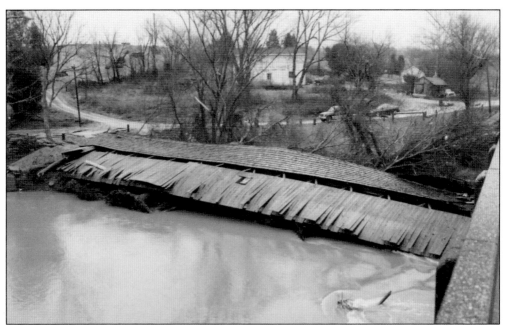

FLOOD-DAMAGED SWITZER BRIDGE. A March 5, 1997, photograph shows the bridge on the banks of the still-swollen North Fork of Elkhorn Creek after being washed off its abutments in the March 3, 1997, flood. In a joint project undertaken by the Kentucky Transportation Cabinet and the Kentucky Parks Department, it was salvaged and reconstructed by Intech Engineering. The bridge had previously received a complete restoration in 1991. (Jurgensen photograph.)

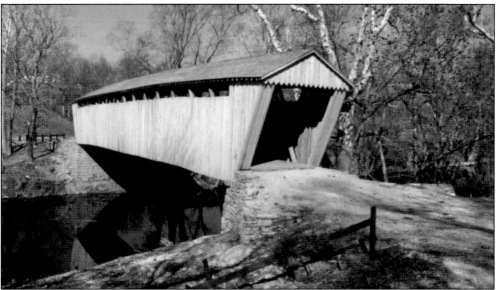

SWITZER BRIDGE. The newly reconstructed Switzer Bridge stands once again overlooking the North Fork of Elkhorn Creek. When the bridge was rebuilt, several arbitrary cosmetic changes were incorporated: the pitch of the roof was increased; a roof overhang was added at the portals; the shelter panels were shortened approximately two feet; and the portal fascia were widened on each side by the width of one sawtooth. This photograph is from November 15, 1999. (Jurgensen photograph.)

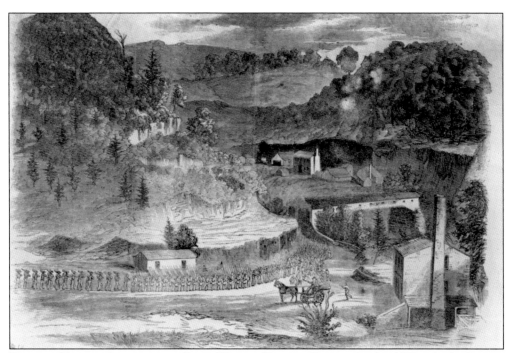

FEDERAL TROOPS CROSSING AT CAMP NELSON BRIDGE. During the Civil War, the bridge was considered important, as it was one of only two highway bridges over the Kentucky River. A company of Union soldiers from the nearby army post was stationed at either end of the bridge to protect it from sabotage.

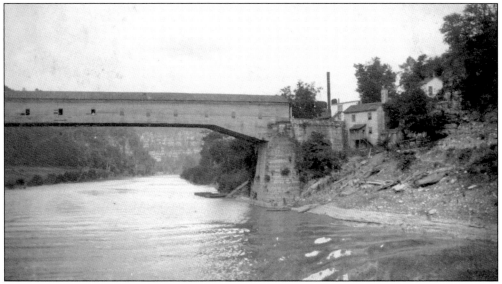

CAMP NELSON BRIDGE. The Camp Nelson Bridge over the Kentucky River at the Garrard–Jessamine County line is likely the best known of all of Kentucky's covered bridges. The double-barrel span was built in 1838 by Lewis Wernwag. At 240 feet, it was, in 1933, the longest single-span wooden bridge in the world. This c. 1910 photograph shows the bridge much as it looked in antebellum days. The louvres were removed when new siding and a new shingle roof were installed about 1915. (Courtesy Kentucky Historical Society.)

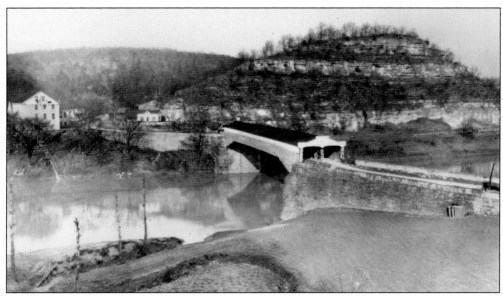

CAMP NELSON BRIDGE AND BOONE'S KNOB. As originally written by J. Winston Coleman in his March 11, 1962 Historic Kentucky column in the *Lexington Herald Leader*, "After nearly 90 years of the bridge's continuous service, a heavily loaded truck from Lexington broke through one of the floorboards that had rotted because of a leaky roof. The old bridge was condemned by the Highway Department and closed to traffic in December 1926. Efforts to preserve the historic structure failed." Lewis Wernwag's Bluegrass masterpiece was intentionally collapsed during demolition on October 19, 1933.

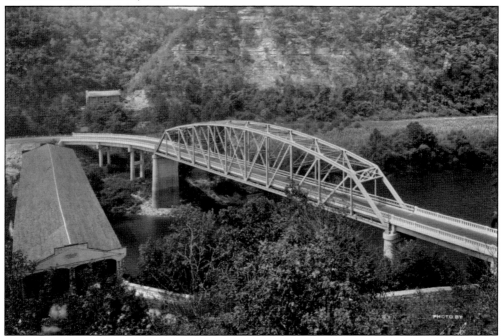

CAMP NELSON BRIDGES. This is the Camp Nelson covered bridge and the steel bridge that replaced it in 1928. In 2004, the steel Camp Nelson Bridge was permanently closed to traffic. (Courtesy Kentucky Historical Society.)

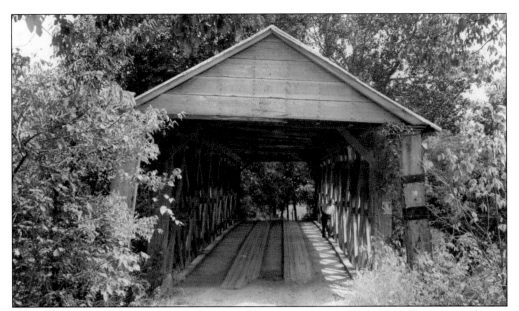

PORTAL VIEW OF HUBBLE ROAD BRIDGE. This is an August 27, 1943, J. Winston Coleman photograph of the portal that greeted travelers on Hubble Road over the Dix River at the Garrard–Lincoln County line for 91 years. Local resident Marvin Brown is one such traveler. He fondly recalls growing up near the bridge and waiting within its portals for the school bus. A sad day for all area residents was June 18, 1955, when the old span was destroyed by arson. The gentleman standing mid-span is identified as Harrison Ester.

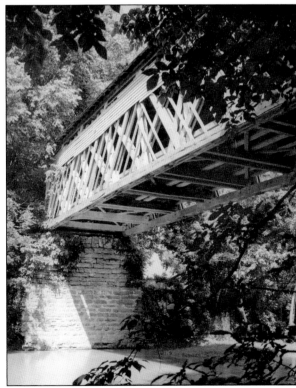

HUBBLE ROAD BRIDGE. This photograph was taken on June 10, 1951. (Courtesy Transylvania University Library, John Thierman Collection.)

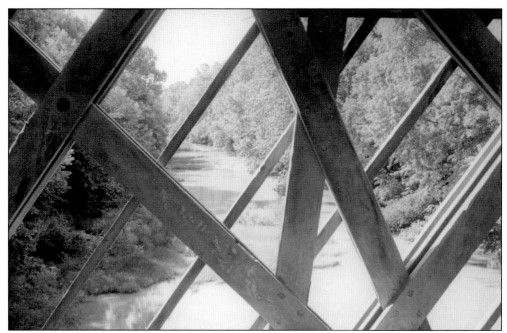

INTERIOR OF HUBBLE ROAD BRIDGE. A June 10, 1951, photograph shows construction details of the Long patent truss. Col. Stephen H. Long was stationed in Louisville just before the Civil War and designed the truss used in many new covered bridges throughout the Bluegrass. Colonel Long did not actually build this bridge, built in 1864 to replace an 1844 covered bridge burned during the war, but the truss is a modified version of his 1858 patent. (Courtesy Transylvania University Library, John Thierman Collection.)

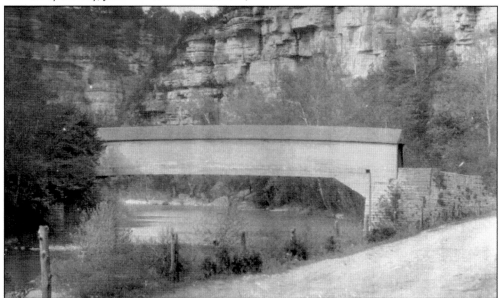

KENNEDY'S MILL BRIDGE. Built over the Dix River on KY 152 by Lewis Wernwag, this 140-foot Wernwag truss is often confused with the nearly identical King's Mill Bridge. Unlike King's Mill, Kennedy's Mill was not a double-barrel bridge. It was replaced by the present Kennedy Bridge in 1925, and its site at the Garrard–Mercer County line is now at the bottom of Herrington Lake.

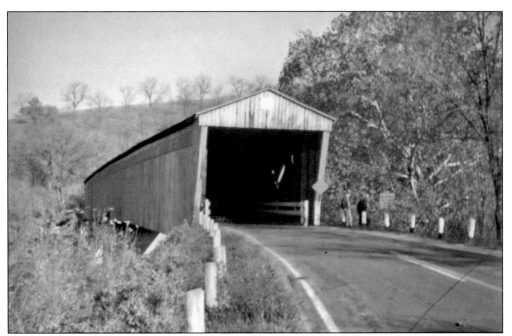

PORTAL VIEW OF CLAYSVILLE BRIDGE. This October 18, 1952, view of the Claysville Bridge was taken just under one year before it burned. Over the Licking River, Claysville was the last covered bridge to carry a federal highway, U.S. 62, in Kentucky. (Courtesy NSPCB Archive, Keller Collection.)

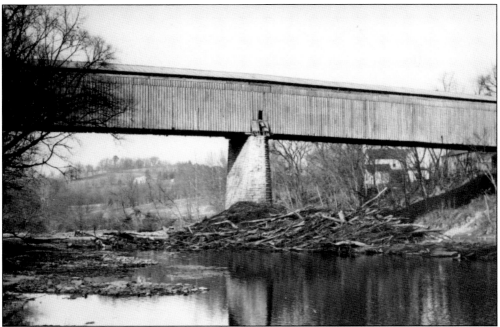

CLAYSVILLE BRIDGE. The 307-foot Howe truss at the Harrison–Robertson County line was the last 300-foot covered bridge in the commonwealth. Built by Jacob Bower in 1874, it was destroyed by fire on September 29, 1953, when a nearby resident burning trash on the riverbank accidentally ignited the drift pile at the center pier. (Courtesy NSPCB Archive.)

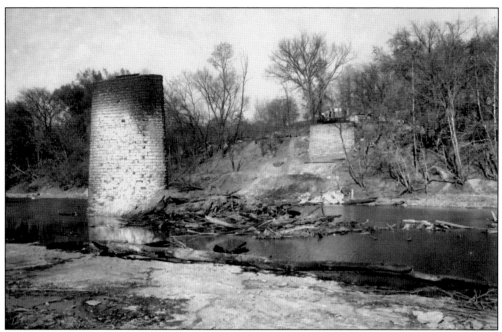

REMAINS OF CLAYSVILLE BRIDGE. This J. Winston Coleman photograph is of the remains of the Claysville Bridge on October 2, 1953. It was reported that the smoke was visible 40 miles to the north in Alexandria, Kentucky, and the smell of burning tar and creosote remained in the air for days.

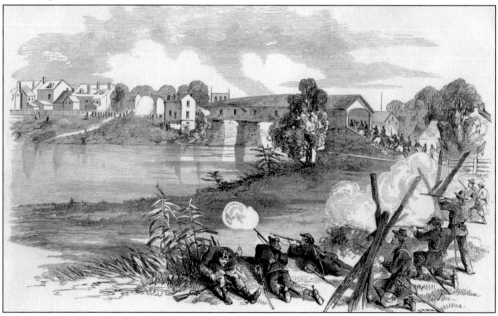

BATTLE OF CYNTHIANA, JULY 17, 1862. This drawing from the pages of *Frank Leslie's Illustrated Newspaper*, August 16, 1862, illustrates the battle fought through the bridge between the Confederate forces of Gen. John Hunt Morgan and the Union troops of Col. John J. Landrum. Landrum preferred exchanging shots with the rebels to burning the bridge, allowing Morgan's Raiders to capture Cynthiana.

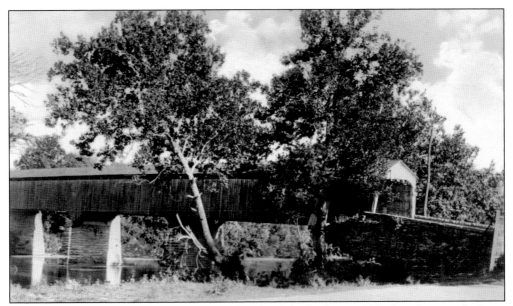

CYNTHIANA BRIDGE. Taken from the south side of the bridge *c.* 1920, this photograph shows the span much as it looked during the Battle of Cynthiana in July 1862. The arched portals were changed by the Kentucky Highway Department in 1926. The 220-foot, three-span Burr arch truss was built by Greenup Remington from plans reportedly drawn by Lewis Wernwag and was removed between the summer of 1946 and December 1948. Even before it was demolished, the old bridge was the subject of artists' brushes and poets' pens. (Courtesy Kentucky Historical Society.)

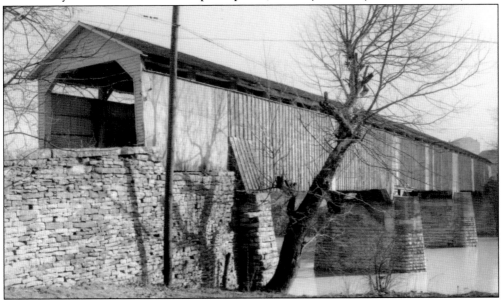

RENOVATED CYNTHIANA BRIDGE. This 1930 photograph shows the angled portal installed by the Kentucky Highway Department in 1926. The original arched portals were changed to provide clearance for modern traffic. Cynthiana carried traffic over the South Fork of the Licking River from 1837 until it was closed in 1944 because it was declared inadequate by the Kentucky Highway Department. Harrison County officials decided to build a new bridge instead of spending $12,000 for repairs.

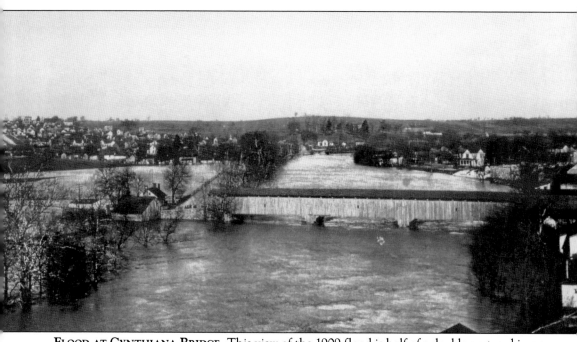

FLOOD AT CYNTHIANA BRIDGE. This view of the 1909 flood is half of a double postcard image taken from the east hills above Cynthiana and clearly shows the windows removed in the 1926 renovation. Also, at the time this picture was taken, concrete icebreakers had not yet been installed on the pier caps. The old iron bridge built on West Pleasant Street in 1905 appears in this photograph just above the covered bridge. (Courtesy Cynthiana–Harrison County Museum.)

DEMOLITION OF CYNTHIANA BRIDGE. This photograph was taken by George Aten during demolition. The bridge had been closed to traffic for two years before the roof, siding, and floor were removed, and the unhoused trusses then stood until they were pushed into the South Licking in December 1948. On Wednesday, December 18, 1946, four men and two teenage girls in a 1936 Ford Coach attempted to cross the floorless bridge. Both young ladies and one of the men were killed in the crash or were drowned. A fourth occupant died the following evening.

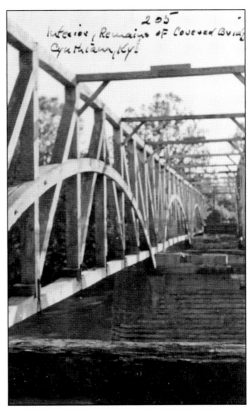

DEMOLITION OF STONEWORK AT CYNTHIANA. A winter 1949 photograph shows the demolition of the stone piers and abutments at Cynthiana in preparation for the construction of the John Hunt Morgan Memorial Bridge. The alignments of the old and new bridges at Cynthiana overlap, and no evidence of the old bridge appears to exist at the site. In summer, when the waters of the South Licking are low, remnants of the pier footings are visible just below the concrete bridge. (Courtesy Filson Historical Society, Louisville, Kentucky.)

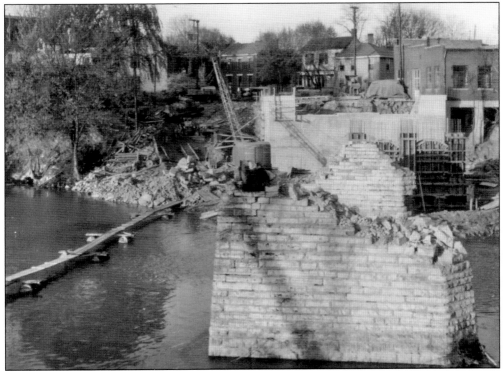

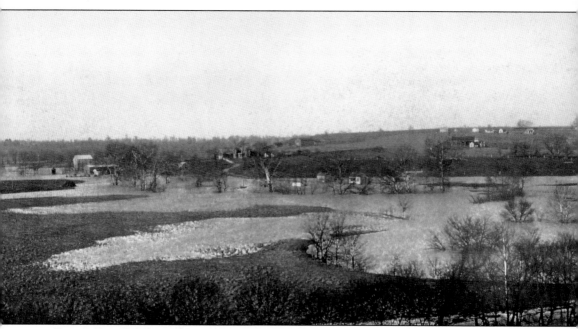

GRAY'S RUN BRIDGE. This image is the other half of the 1909 Cynthiana flood postcard. The 100-foot bridge over Gray's Run on U.S. 68 in Harrison County is the structure on the far left of the photograph. Not as well remembered as the Cynthiana Bridge a half mile north, the Gray's Run Bridge remained in use into the 1920s. (Courtesy Cynthiana–Harrison County Museum.)

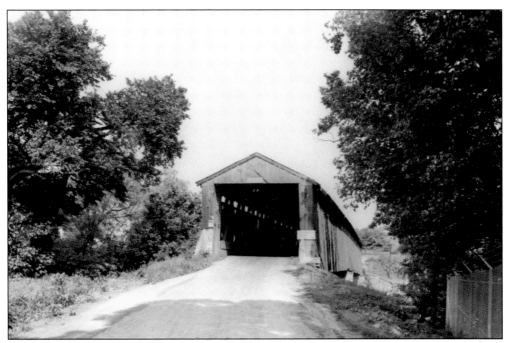

LAIR STATION BRIDGE. This 270-foot Howe truss was built by John and Matthias [*sic*] Lair and T. J. Megibben in 1871 over the South Licking on what would become the Old Lair Road in Harrison County. J. Winston Coleman photographed this view on May 20, 1942.

IRONY AT THE LAIR STATION BRIDGE. On July 11, 1946, Harrison County Judge-Executive W. E. Boswell and County Engineer W. H. Criswell inspected the old bridge and posted it condemned; 30 minutes later, the north span collapsed. This photograph by J. Winston Coleman on July 12 shows the collapsed remains before a carelessly tossed cigarette burned it five days after it fell. The remaining span was later removed to facilitate construction of the new concrete bridge.

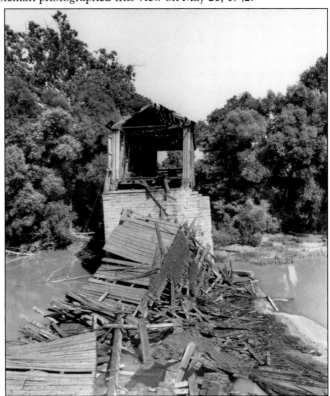

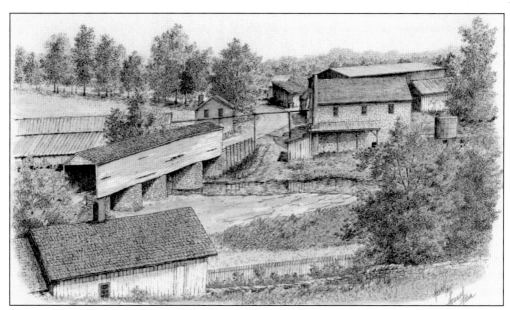

UNION MILLS BRIDGE. The 150' bridge at Union Mills over Hickman Creek on Ky 169 in Jessamine County was lost in a flash flood on August 2, 1932. The Elm Fork and Sugar Creek Pike covered bridges in Jessamine County were lost in the same flood. An abandoned, four span stell bedstead and pony truss currently stands on the old stonework at Union Mills.. (Drawing by Howard Fain.)

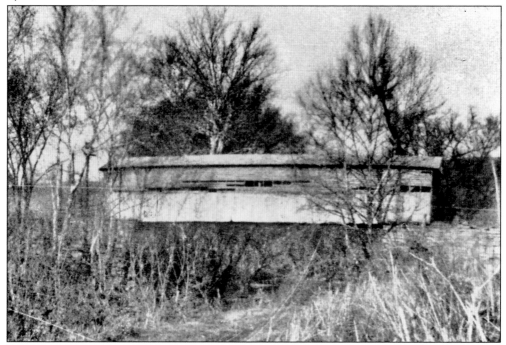

HANGING FORK BRIDGE. This 1930s photograph shows the old bridge over Hanging Fork on U.S. 150 in Lincoln County. The lines of the bridge suggest that the truss design may have been a McCallum's Arched Inflexible. The 100-foot span was replaced by concrete in the 1940s. (Courtesy Delbert and Lucille Crawford.)

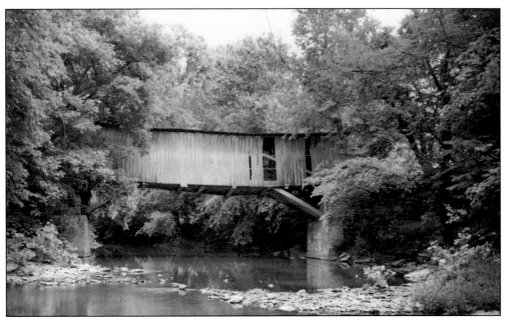

FORSYTH MILL BRIDGE. This long-deteriorated bridge carried VanArsdale Road in Mercer County. Bypassed by a steel pony truss in 1937, the covered span remained for local use. The 60-foot bridge was too long a crossing for the lightly built queenpost trusses and was never adequately repaired. Propped and patched many times, the weakened span collapsed into the Salt River in 1955. (Courtesy Transylvania University Library, John Thierman Collection.)

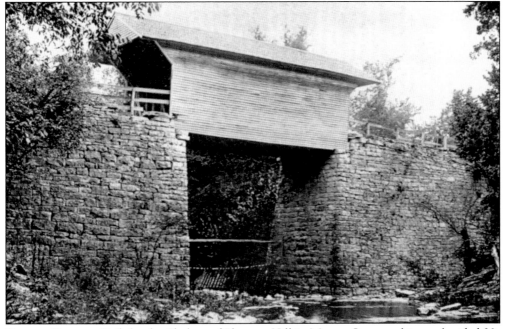

KISSING BRIDGE. Built by the Shakers of Pleasant Hill in Mercer County, this neatly sided 30-foot kingpost truss over Shaker Run on U.S. 68 near Shakertown was replaced by concrete in 1925. Since the 1970s, plans to rebuild the covered bridge at the now abandoned crossing have been discussed but have never come to fruition.

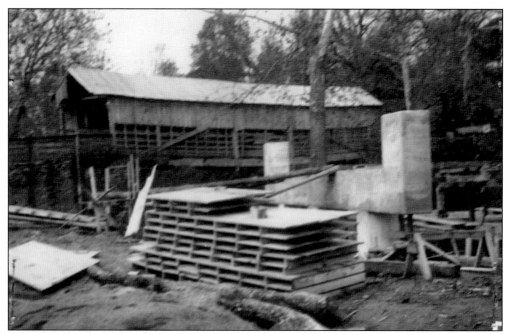

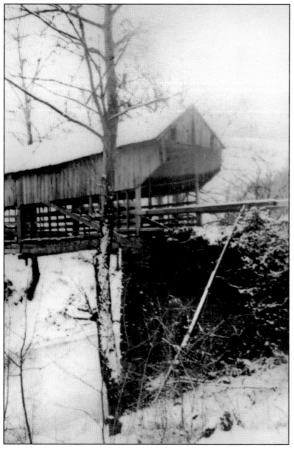

KIRKWOOD PIKE BRIDGE. This 90-foot queenpost truss crossed the Salt River in northwestern Mercer County near Salvisa. The vertical furring strips indicate that the original siding was likely horizontal. The weathered span was demolished when the road was realigned, and a concrete replacement bridge was built in 1936. The stone abutments still exist at the site. (Courtesy University of Kentucky Special Collections, George Goodman Collection.)

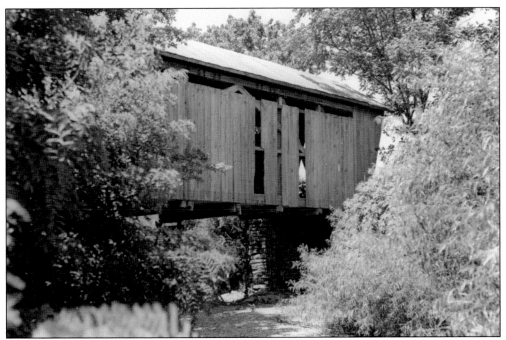

UPPER SHARPSBURG ROAD BRIDGE. The last 2 of 15 known covered bridges entirely within Nicholas County were on the Upper and Lower Sharpsburg Roads. The 75-foot combination kingpost/multiple kingpost bridge on the upper road over East Fork was replaced in 1956. (Courtesy Transylvania University Library, John Thierman Collection.)

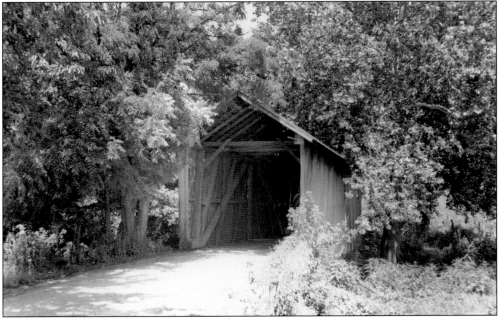

LOWER SHARPSBURG ROAD BRIDGE. With the exception of fancy sawtooth portals and full-height siding, the covered bridge on the lower road over Somerset Creek was a duplicate of the span on the Upper Sharpsburg Road. It was replaced in 1957. (Courtesy Transylvania University Library, John Thierman Collection.)

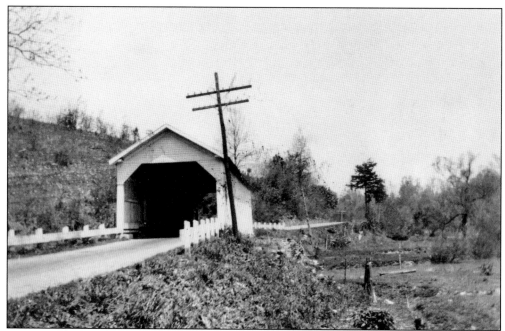

STONY CREEK BRIDGE. One of three covered bridges within two miles of each other on U.S. 68 in Nicholas County, this bridge crossed Stony Creek two miles southwest Blue Licks. The 75-foot, single-span queenpost truss was repaired by the Kentucky Highway Department in 1926 and was replaced by concrete in the 1930s. (Courtesy Kentucky Historical Society.)

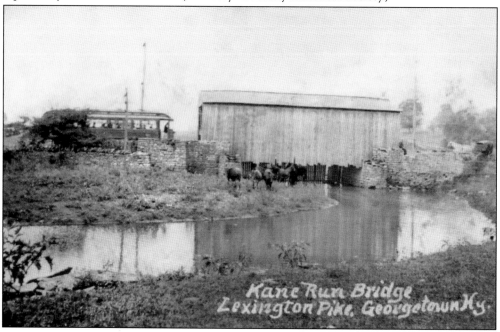

CANE RUN BRIDGE. This view of the originally horizontally sided Cane Run Bridge shows when it carried the Frankfort-Georgetown Interurban Railway and U.S. 460 over Cane Run in Scott County. Boxed interior buttresses on this bridge were a unique feature on a Kentucky covered bridge. A steel pony truss replaced this 60-foot queenpost truss in the 1920s.

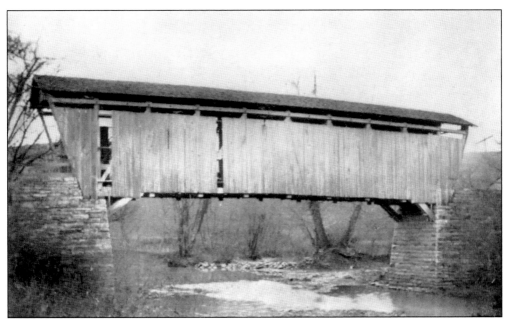

SADIEVILLE BRIDGE. This bridge crossed Eagle Creek on KY 32 near Sadieville in Scott County. The 90-foot span was a multiple kingpost truss with added arches. (Courtesy Mary Pat Kroger.)

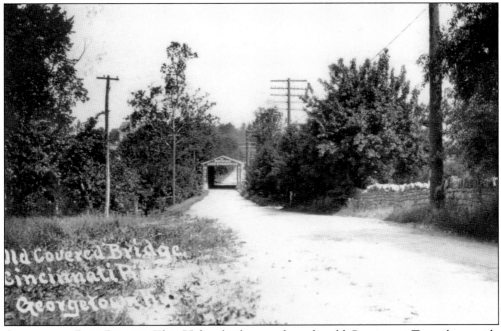

CINCINNATI PIKE BRIDGE. This 75-foot bridge stood on the old Cincinnati Turnpike outside Georgetown in Scott County. It crossed the North Fork of Elkhorn Creek until replaced by a steel pony truss in 1932. The replacement bridge utilizes the stone abutments of the old span and continues to carry traffic on U.S. 25.

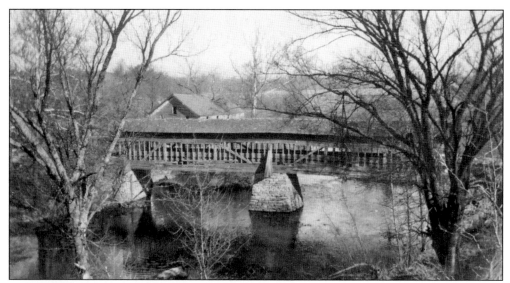

FISHERS MILL BRIDGE. Though officially credited to Harrison County's Cynthiana Bridge in 1937, Kentucky's oldest covered bridge at that time was actually the Fishers Mill Bridge over Elkhorn Creek at the Scott–Woodford County line. Built in 1810, it was a 140-foot, two-span queenpost truss with flying buttresses. In this 1911 view, the mill was still standing in the background. The 137-year-old bridge was replaced in 1947.

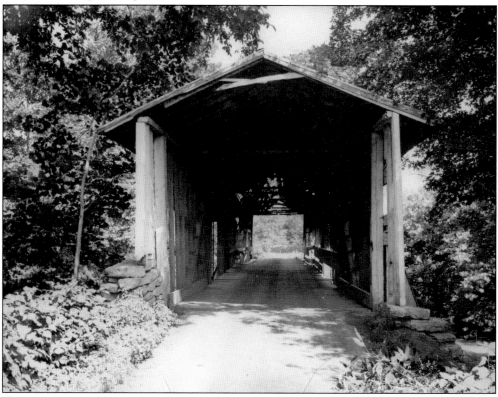

ENTERING THE FISHERS MILL BRIDGE. This 1944 J. Winston Coleman photograph shows the Woodford County portal of the ancient structure.

Eight

THE GATEWAY AND THE BUFFALO TRACE

The Gateway Area Development District is Kentucky's gateway to the mountains. Although no covered bridges have been discovered to have existed in the Big Sandy and the Kentucky River Area Development Districts to the southeast, at least 20 covered bridges provided gateway crossings to the Appalachian Mountains. The peaks of eastern Kentucky begin as foothills and valleys that wind their way through Bath, Menifee, Montgomery, Morgan, and Rowan Counties. These valleys were cut by ancient rivers that became the tributaries of Slate Creek, Brush Creek, and the Red and the Licking Rivers.

Wagons and carriages that followed the Midland Trail through the Gateway counties on their way to the Cumberland Gap crossed covered bridges at Upper and Lower Spencer, West Liberty, Wyoming, Midland, and Nada. These were not always the masterful structures of Wernwag and Long but were mostly hardy pioneer spans built quickly and with economy in mind. One Gateway bridge survived into the 1950s, carried not by limestone abutments but supported by an odd assortment of timber piles resting on stone and later concrete on the banks of Slate Creek. The last covered bridge in the Gateway ADD (and shared by the Buffalo Trace) is long lamented by Licking River Valley residents, it having been destroyed by teenage arsonists in 1981.

Long before Roy Rogers sang of their westward migration, the buffalo roamed the passages of northeastern Kentucky known as the Buffalo Trace Area Development District. Although few in remaining number, covered bridges continue to stand in each of the five counties of the Buffalo Trace ADD. The Limestone Road began at Maysville, then known as Limestone, and, though never finished as planned, worked its way through the commonwealth. Lewis Wernwag was for a time a resident of Mays Lick in Mason County and built many sturdy queenpost trusses on the crossings of the Macadam turnpikes through Bracken, Fleming, Lewis, Mason, and Robertson Counties. Today Fleming County (once the home of Kentucky's last covered bridge man, Stock Bower, and still home to three Bower-maintained covered bridges) proudly proclaims itself "the Covered Bridge Capital of Kentucky."

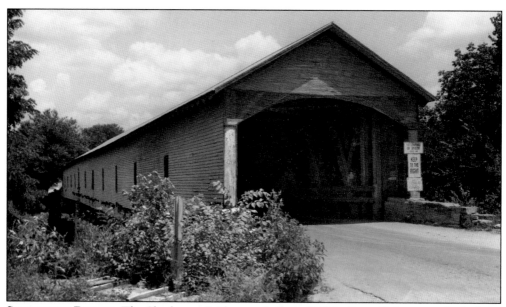

SHERBURNE BRIDGE. The Sherburne Bridge was built in 1867 by Isaac Kisker over the Licking River on the Flemingsburg–Mount Sterling Turnpike at the Bath–Fleming County line. This view shows the bridge before steel tiers and suspension cables were added in 1951. This addition led to the bridge being classified as "a covered suspension bridge." It was not. Sherburne was a covered bridge with added suspension elements. Bypassed in 1977, the 263-foot Howe truss, then Kentucky's longest covered bridge, was destroyed by arson April 6, 1981.

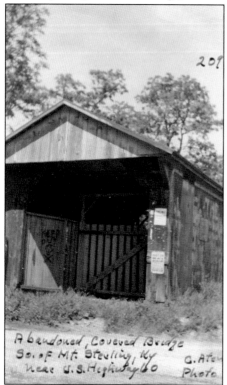

NEAR MOUNT STERLING. The handwritten caption on this 1944 photograph by George Aten reads, "Abandoned covered bridge So. of Mt. Sterling, Ky near U.S. Highway 60." U.S. 60 runs basically east-west through Montgomery County. The most likely location for this bridge based upon Aten's description was over Somerset Creek on an old alignment of the federal highway approximately three miles southwest of Mount Sterling. (Courtesy Mary Pat Kroger.)

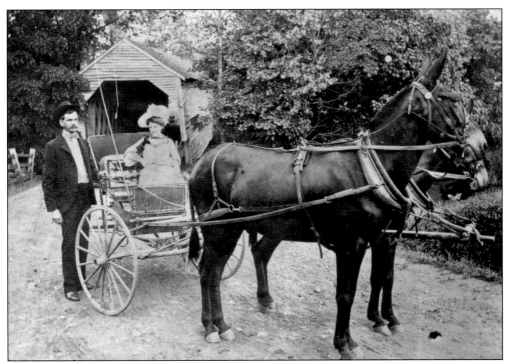

SUMMER AT THE SLATE CREEK BRIDGE. This 1902 photograph is the earliest known image of the old Town lattice bridge over Slate Creek in Montgomery County. The couple posing for the photographer is Mr. and Mrs. Thomas H. Greenwade. This last covered bridge in Montgomery County was demolished in 1954 when the crossing was realigned downstream.

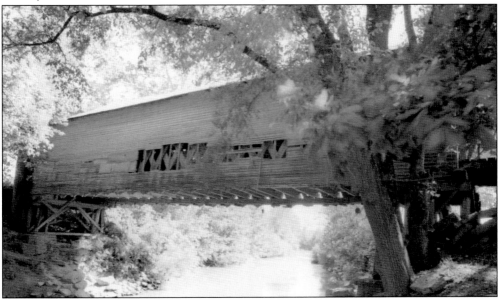

SLATE CREEK BRIDGE. Unique among Kentucky's covered bridges, Montgomery County's Slate Creek Bridge on the Upper Spencer Road over Slate Creek was supported by timber piling instead of stone abutments. It is shown here on April 24, 1952. (Courtesy Transylvania University Library, John Thierman Collection.)

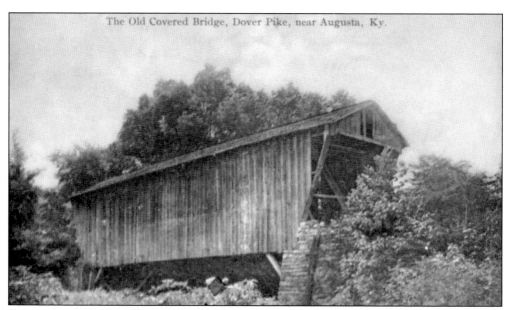

The Old Covered Bridge, Dover Pike, near Augusta, Ky.

DOVER-AUGUSTA PIKE BRIDGE. This bridge stood on the Dover-Augusta Pike between Augusta and Minerva over Little Bracken Creek in Bracken County. It is sometimes confused with the Dover Covered Bridge that still stands on Tuckahoe Road in Mason County. The steel camelback truss that replaced this bridge and the old stone abutments were removed summer 2007 when a new concrete bridge was built at a slightly different alignment.

WALCOTT BRIDGE. This is the Walcott Bridge on October 18, 1952, when it was open to traffic. Built in 1880 to replace an 1824 covered bridge at the same location on KY 1159 over Locust Creek in Bracken County, the 100-foot span utilized a combination multiple kingpost and queenpost truss. Local resident G. N. Murray formed the Bracken County Historical Society and led a successful effort to save the bridge, bypassed in 1954 when the crossing was realigned, after having been originally scheduled for demolition. (Courtesy NSPCB Archive, Keller Collection.)

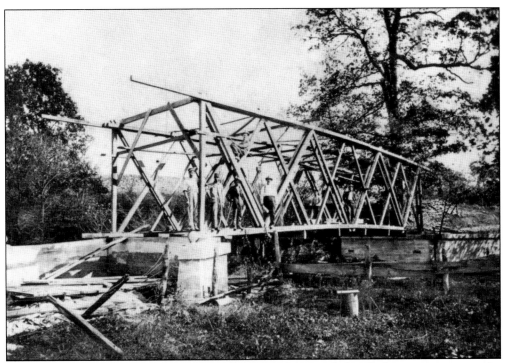

CONSTRUCTION OF DALESBURG BRIDGE. This 1909 photograph details the construction on the Dalesburg Bridge by the Bower Bridge Company.

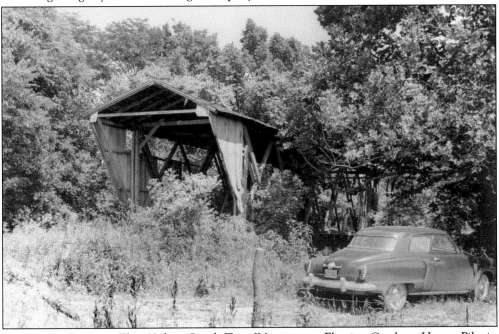

DALESBURG BRIDGE. This 60-foot, Smith Type IV truss over Fleming Creek on Hussey Pike in Fleming County was the last Kentucky covered bridge built by the Bower Bridge Company. The 43-year-old span was replaced by concrete in 1952 after it was collapsed by a truck attempting to cross. (Courtesy Transylvania University Library, John Thierman Collection.)

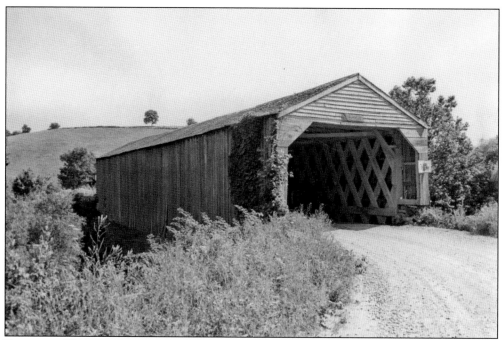

ELIZAVILLE-HILLTOP BRIDGE. On KY 170 over Fleming Creek in Fleming County, this 98-foot Town lattice truss was a favorite of Kentucky's last covered bridge builder, Stock Bower. In 1956, a metal roof replaced the aging shingles and new siding was installed on the portals. This repair did not save the bridge. This July 2, 1946, J. Winston Coleman photograph was taken 14 years before it was dynamited out of existence.

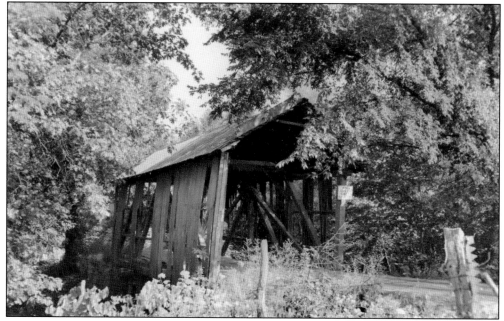

FOXPORT BRIDGE. This combination kingpost and queenpost bridge carried KY 57 over the North Fork of the Licking River at the Fleming–Lewis County line. In 1954, the 90-foot span was replaced by concrete. (Courtesy Transylvania University Library, John Thierman Collection.)

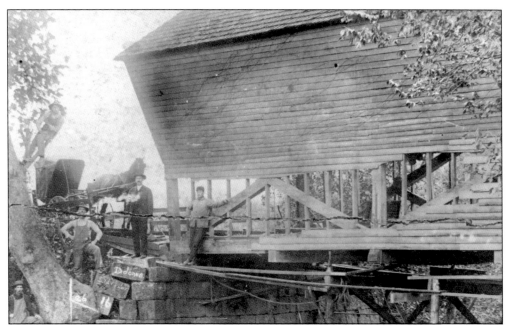

FOX SPRING ROAD BRIDGE. This is a Bower photograph of the old queenpost bridge over Fleming Creek in Fleming County. The 56-foot, horizontally-sided, single-span bridge was replaced by concrete in the 1940s. From left to right, David Jones, Louis Bower, and an unidentified worker pose with the mare Patsy next to the bridge.

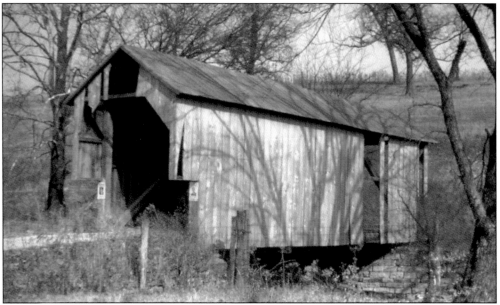

POPLAR PLAINS BRIDGE. The Poplar Plains Bridge on KY 1515 over Locust Creek is pictured on November 2, 1952. The date of construction of this 40-foot queenpost truss in Fleming County is unknown. Bypassed in the mid-1950s, the bridge was turned over to the owner of the adjacent property and spent its last years used for hay storage. In 1963, the property owner decided that there was a possibility of fire and had the bridge demolished. (Courtesy NSPCB Archive, Keller Collection.)

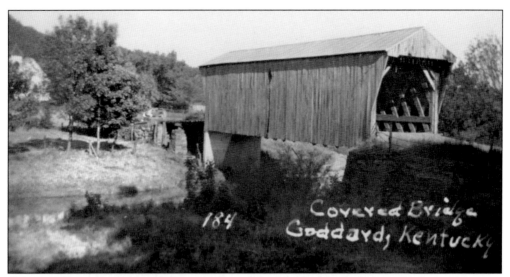

184 Covered Bridge
Goddard, Kentucky

GODDARD BRIDGE. Although the exact date of the Goddard Bridge's construction is unknown, Stock Bower believed it to have been 1864. In 1932, the 63-foot Town lattice span was moved by the WPA two miles north to its present location over Sand Lick Creek on Goddard–Muses Mill Road in Fleming County. During construction of the concrete pier, the *Graf Zeppelin* is reported to have flown overhead. No photograph of the bridge at its original location on KY 32 has been discovered.

EARLY GRAFFITI IN GODDARD BRIDGE. The Town lattice truss of the Goddard Bridge is covered with initials that have been carved over many generations. Because of its proximity to the Goddard Methodist Church, the picturesque scene has appeared in numerous publications from travel brochures to car magazines. Goddard is probably the most photographed covered bridge in Kentucky. (Jurgensen photograph.)

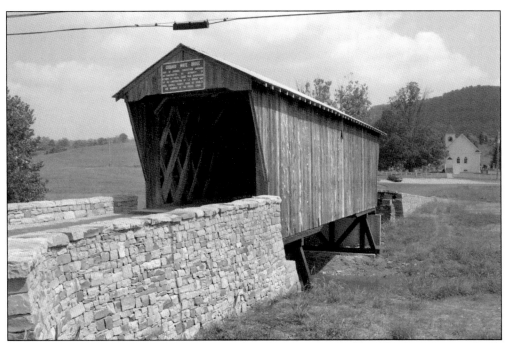

RESTORED GODDARD BRIDGE. From 2004 though 2006, the Goddard Bridge was completely renovated. Most of the original timbers were reused, and the local community was heavily involved in the project. The most noticeable change is the addition of the dry stone wingwalls and parapets. (Jurgensen photograph.)

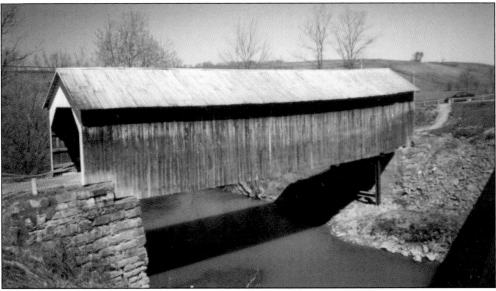

GRANGE CITY BRIDGE. The 86-foot multiple kingpost truss Grange City or Hillsboro Bridge carried traffic on KY 111 over Fox Creek in Fleming County until it was bypassed in 1968. Built in 1867 as a twin to the nearby Ringo's Mill Bridge, over time, its appearance has been changed. In 1926, the horizontal wood siding was replaced with corrugated sheet metal and the portals were altered. Minor restoration work was undertaken in 1983 when the metal siding was replaced with wood. (Jurgensen photograph.)

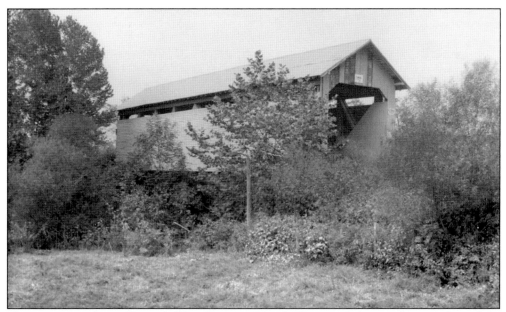

HORIZONTALLY SIDED RINGO'S MILL BRIDGE. This J. Winston Coleman photograph is of the bridge over Fox Creek on September 11, 1943. Fox Creek was named for a gentleman by the name of Fox who had drowned in the creek years earlier. Covered bridges also once existed in Kentucky at places named John's Mill, Paul's Mill, and George's Mill.

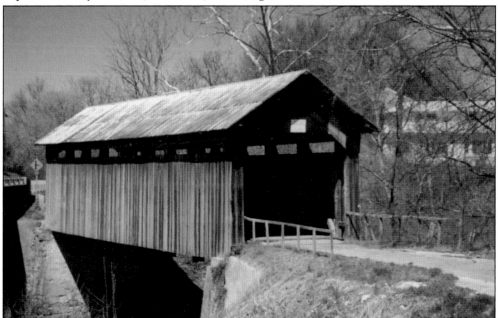

RINGO'S MILL BRIDGE. Closed to traffic in 1970, the Ringo's Mill Bridge has crossed Fox Creek on KY 158 in Fleming County since 1867. The 86-foot multiple kingpost truss was renovated in 1983, and its original horizontal siding was replaced by vertical weatherboarding. Stock Bower began this renovation, but he was unable to complete the project after being stricken suddenly with macular degeneration. Although Stock remained as a consultant, LeRoy and Gary Wood of Brooksville, Kentucky, completed the project. (Jurgensen photograph.)

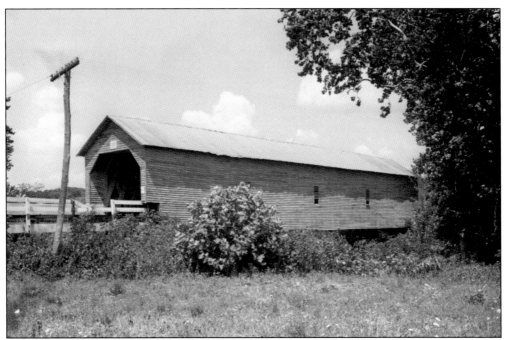

RIBOLT-TOLLESBORO BRIDGE. Four covered bridges remained in use in or at Lewis County prior to 1947. Ten years later, the count was one. This 110-foot Town lattice carried Old KY 10 over Cabin Creek west of Ribolt. It was built in 1871, photographed by J. Winston Coleman on August 4, 1944, and demolished in late summer 1956.

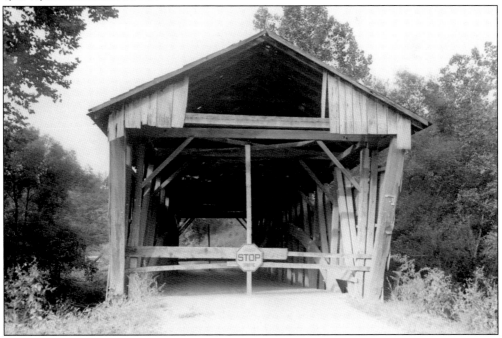

TOLLESBORO-CONCORD BRIDGE. This bridge, a 110-foot Burr arch truss on KY 57 over Cabin Creek in Lewis County, was replaced by concrete soon after this September 24, 1947, photograph by J. Winston Coleman was taken.

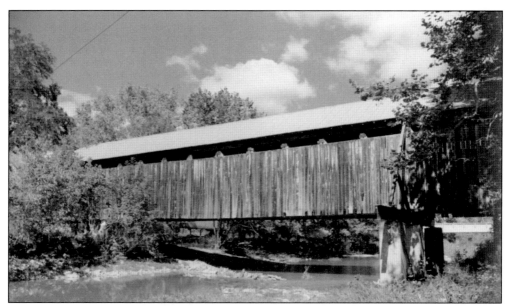

CABIN CREEK BRIDGE AND BUTTRESS. Like many covered bridges in the area, the Cabin Creek Bridge was repaired by the Bower Bridge Company. The arches and iron tension rods were added during this repair in 1912. The placement of these tension rods have led to the recent misclassification of this bridge as a Childs truss. Today the bridge is in a state of technical collapse, supported only by the steel buttress added *c.* 1978. Restoration funding is pending. (Laughlin photograph.)

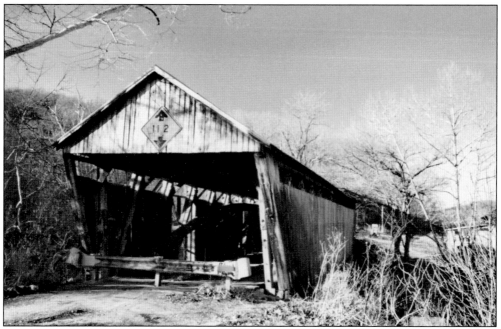

CABIN CREEK BRIDGE. This 114-foot multiple kingpost truss is the last of eight known covered bridges that once stood in or at Lewis County. The Cabin Creek Bridge, closed to traffic in 1983, crosses the creek of the same name on an abandoned alignment of KY 984 within sight of the Mason County line. (Jurgensen photograph.)

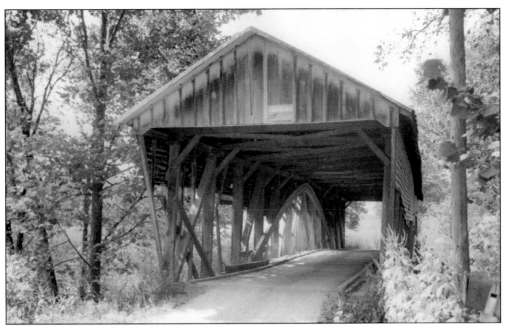

DIXON PIKE BRIDGE. This 120-foot multiple kingpost truss carried Dixon Pike over the North Fork of the Licking River in Mason County. The date of construction is unknown, but the arches were added by the Bower Bridge Company in 1912; the concrete center pier was added by the Mason County Road Department in 1924. In 1947, a steel camelback pony truss replaced this bridge.

HELENA-WEDONIA BRIDGE. This 60-foot, single-span bridge over Mill Creek on KY 324 in Mason County was repaired by the Bower Bridge Company in 1915. The vertical siding and battens were removed by the Kentucky Highway Department in 1926, as shown in this 1946 Harold Rhodenbaugh photograph. This unusual multiple kingpost camelback truss was replaced in 1947. (Courtesy the *Courier-Journal*.)

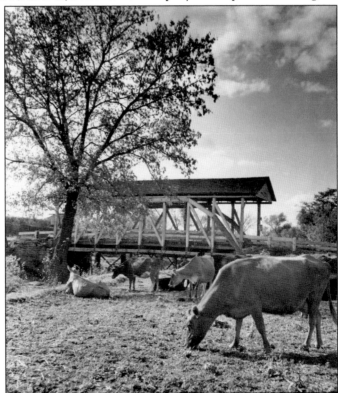

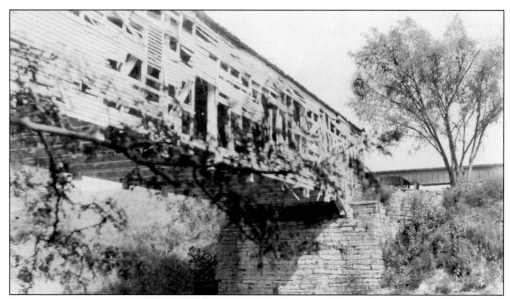

LEWISBURG BRIDGE. A 1925 Bower Bridge Company photograph shows the remains of the original horizontal siding and louvres. The 90-foot covered bridge at Lewisburg carried the old alignment of KY 10, now KY 419, over the North Fork of the Licking River in Mason County. The siding was removed by the Kentucky Highway Department in 1926. Unusual for a covered bridge in the commonwealth, it was constructed with a double-web Burr arch truss. The Lewisburg Bridge was replaced by concrete in 1940.

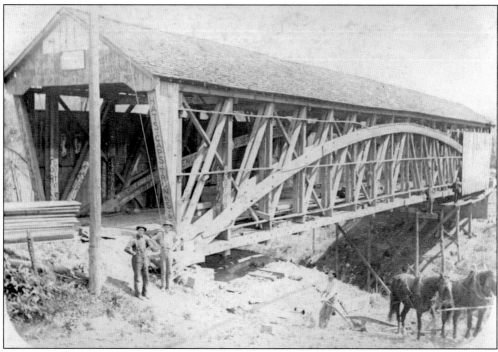

MAYS LICK BRIDGE. This *c.* 1905 photograph shows the bridge on Old U.S. 68 over Lee's Creek in Mason County under repair by the Bower Bridge Company. This 160-foot Burr arch truss, adorned with advertisements for several Maysville businesses, was replaced by concrete in 1925.

REPAIRS TO MURPHYSVILLE BRIDGE. This 1914 Bower Bridge Company photograph shows repair of the combination multiple kingpost and queenpost trusses. The laminated arch appears to have been an earlier attempt at repair.

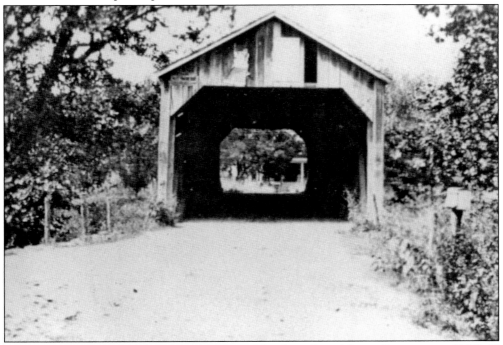

MURPHYSVILLE BRIDGE. The covered bridge at Murphysville in Mason County carried U.S. 62 over the North Fork of the Licking River. It was replaced in 1930.

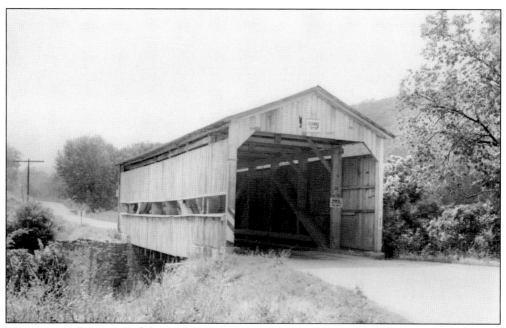

MORANBURG BRIDGE. Built by Lewis Wernwag in 1832, this 75-foot queenpost truss over Lawrence Creek at the Mason County community of Moranburg remained in service until replaced by concrete in 1947. The bridge was repaired by the Kentucky Highway Department in 1926, and the original horizontal siding was replaced with vertical. The full-length window visible in this July 5, 1942, J. Winston Coleman photograph was added in 1926 to allow visibility of the intersection of Old KY 10 and KY 1597.

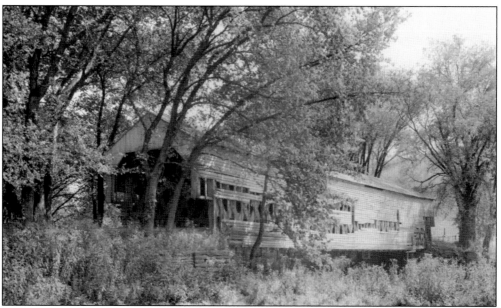

OLD CANNON BRIDGE. This is an August 30, 1945, J. Winston Coleman photograph of the Old Cannon Bridge on Mount Carmel Pike, over the North Fork of the Licking River in Mason County. The date of construction and origin of the unusual name of the 120-foot Town lattice truss are unknown. The bridge was replaced in 1947.

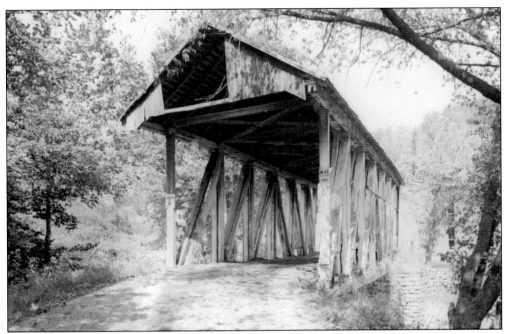

RIPLEY FERRY PIKE BRIDGE. Nearly abandoned in its last years after being bypassed by a culvert in the late 1930s, this 60-foot multiple kingpost truss over Lawrence Creek remained open to traffic on the little-used old alignment of Ripley Ferry Pike in Mason County. This July 5, 1942, J. Winston Coleman photograph is among the last ever taken of the nearly forgotten bridge. It had disappeared by 1947.

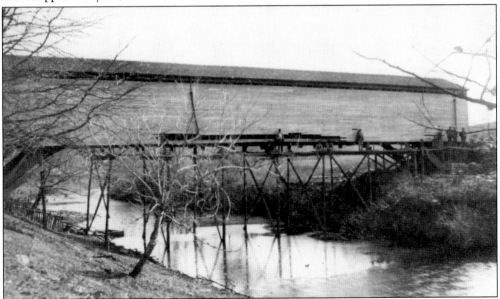

TANGLETOWN BRIDGE. Shown during a c. 1905 Bower Bridge Company repair, this 140-foot span carried KY 616 over the North Fork of the Licking River at the Mason–Robertson County line. The date of original construction and the date and method of its destruction are unknown. The stone abutments in this photograph still exist but have been unused since the road was realigned in 1966.

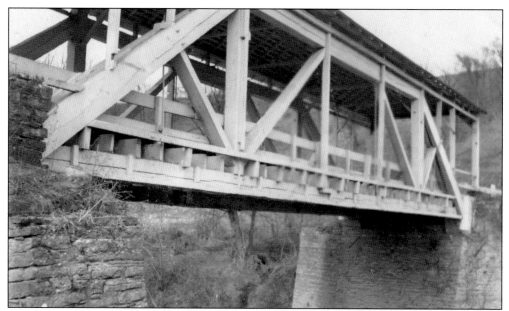

RED LINED WELLS FORK BRIDGE. This 90-foot span was built over the North Fork of the Licking River near Mays Lick in Mason County in 1865 to replace a covered bridge burned during the Civil War. In 1926, the siding was removed from this bridge, exposing the queenpost trusses.

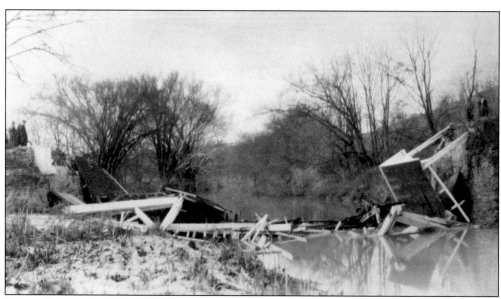

WELLS FORK BRIDGE. Paint did not provide protection for the trusses of covered bridges from which the siding was removed by the Kentucky Highway Department, as evidenced by this January 1937 James Pyles photograph. The bridge was collapsed by a farm tractor attempting to cross the deteriorated span. The tractor driver survived the accident.

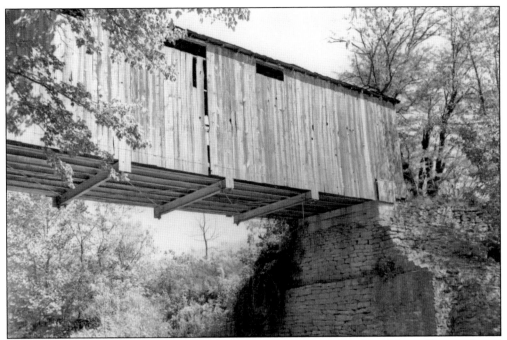

DOVER BRIDGE. The Dover Bridge was built in 1835 over Lee's Creek in Mason County. It was renovated by the Bower Bridge Company in 1912 and was raised to its current height by 15-year-old Stock Bower in 1920. This September 16, 1951, photograph shows the original stone abutments and the concrete added when the bridge was raised. Bypassed in 2005, the 60-foot modified queenpost truss still carries traffic on Tuckahoe Road just off KY 8. (Courtesy Transylvania University Library, John Thierman Collection.)

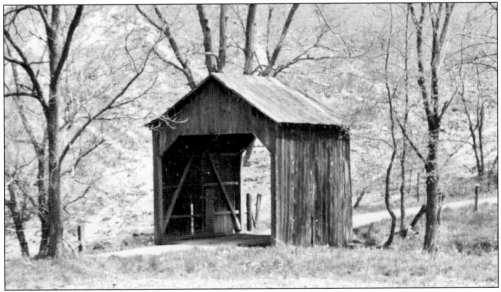

VALLEY PIKE BRIDGE. Perhaps the shortest known covered bridge to have existed in Kentucky has carried the Bouldin driveway over Lee's Creek since 1864. The 24-foot kingpost truss off Valley Pike in Mason County is Kentucky's only privately owned authentic and vintage covered bridge. (Jurgensen photograph.)

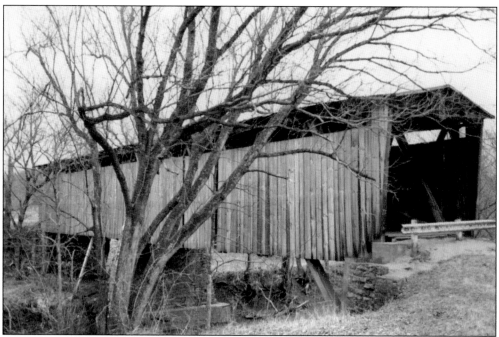

JOHNSON CREEK BRIDGE AWAITING RESTORATION. The only surviving covered bridge in Robertson County stands off KY 1029 near the Blue Licks Battlefield State Park. Jacob Bower constructed the 110-foot, Smith Type IV truss in 1874. In 1912, the Bower Bridge Company repaired and added arches and tension rods to the trusses. An off-center pier was later added, not by Bower, and in large part due to uneven stresses caused by the improperly positioned pier, over the years, the bridge has fallen into disrepair. (Jurgensen photograph.)

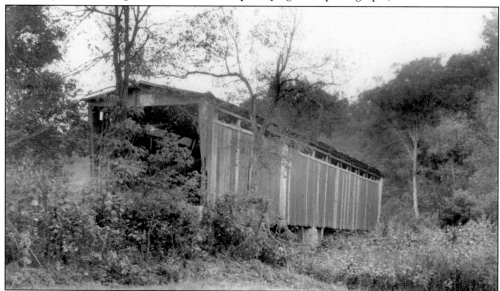

JOHNSON CREEK BRIDGE. This September 23, 1951, photograph shows the bridge over Johnson Creek when it was still open to traffic. Remnants of the original red paint can clearly be seen on some of the weatherboards. The Johnson Creek Bridge is slated for restorati.on in 2007. (Courtesy Transylvania University Library, John Thierman Collection.)

Nine

FIVCO

The spokes of the covered bridge wheel of Kentucky radiate from the Bluegrass hub, once home to over 250 covered bridges, in all directions, dwindling in known number as it reaches the river and mountain rims of the state lines. The easternmost covered bridges in Kentucky were and are found in the Five County (FIVCO) Area Development District. At least 18 timbered tunnels are known to have once stood sentinel in such unusually named places as Barbecue Road, Argillite, Leon, and Enterprise. Iron was once produced in great numbers in this region, and although their blasts ended over a century ago, ruined sandstone rhomboids that were iron furnaces stand within view of most of the covered bridge sites in Boyd, Carter, Elliot, Greenup, and Lawrence Counties. One of the remaining covered bridges, Bennett's Mill, gives monument to the old Globe Furnace, its abutments constructed from the dressed sandstone that once provided the fire that forged the hand-wrought spikes and nails of other covered bridges throughout the FIVCO ADD.

Isaac Wheeler of Sciotoville, Ohio, perfected his truss design over such streams as the Little Sandy River, Tygarts Creek, and Little Blaine Creek in Greenup and Lawrence Counties. At least four of these spans with their odd secondary chords were built in Kentucky before he returned across the Ohio River and dotted the landscape of the southeastern Buckeye State with these stout bridges. In Greenup County, the prototype and sole survivor of Wheeler's legacy in wood remains, restored and continuing to carry tourists, travelers, dobbin, and Dodge through its solitary tunnel.

Boyd County's Barbecue Road Bridge was destroyed during the Civil War by future president Maj. James A. Garfield. Carter County's last covered bridge, at Carter City, was replaced in the 1930s without the fanfare worthy of its years of service. Maloneton's Bridge in Greenup County collapsed into Tygarts Creek abandoned and forgotten, and Lawrence County's last covered bridge, saved from demolition and newly painted in the 1960s, crashed into the waters of Blaine Creek in 1986, leaving the count of the FIVCO covered bridges at two.

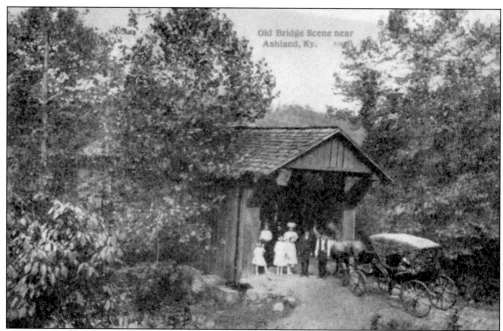

CROSSING THE DANLEYTON BRIDGE. On KY 503 over the Little Sandy River in Greenup County, this 110-foot Wheeler truss was replaced by a concrete bridge at a different alignment in 1955.

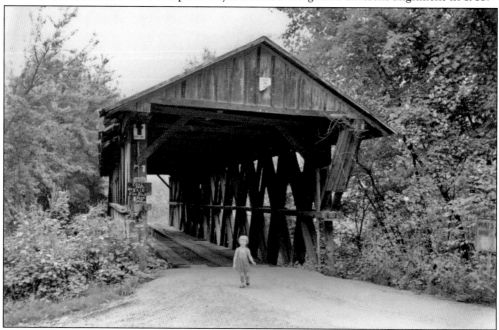

DANLEYTON BRIDGE. Several Greenup County covered bridges were Wheeler trusses. Isaac Wheeler patented his truss in 1870, 15 years after construction of the Bennett's Mill Bridge, generally accepted as the prototype. A common reflection in Greenup County and among the descendants of B. F. and Prameley [sic] Bennett is that Wheeler copied his design from their unpatented truss. The child in this September 2, 1951, photograph of the Danleyton Bridge is unidentified. (Courtesy Transylvania University Library, John Thierman Collection.)

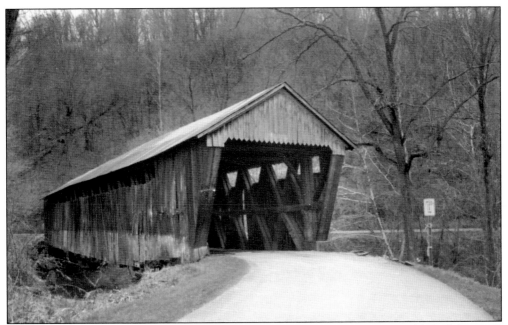

BENNETT'S MILL BRIDGE. When brothers Prameley [sic] and B. F. Bennett established their mill on the banks of Tygarts Creek in Greenup County, they built a bridge to allow customers from "across the creek" to reach their business with ease. In 1855, this 170-foot, single-span Wheeler truss was constructed. After being damaged by the March 1997 flood—note the waterline on the side of the bridge—it was renovated and raised three feet in 2004 by the Kentucky Transportation Cabinet and Intech Engineering. (Jurgensen photograph.)

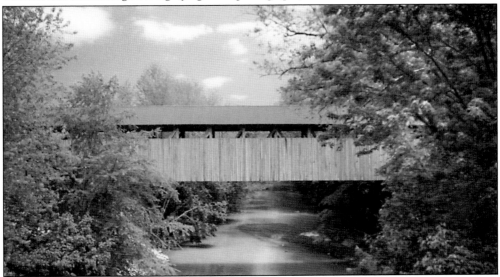

OLDTOWN BRIDGE. The Oldtown Bridge has stood on Frazier Branch Road in Greenup County over the Little Sandy River since 1880. The Bower Bridge Company repaired the bridge in 1913, adding iron tension rods to the 190-foot multiple kingpost span. It was again restored in 1971 by the Green Thumb Society superintended by J. L. "Lafe" O'Bryan, but it deteriorated over time from heavy traffic loads, which necessitated its closure in 1985. From 1999 to 2000, the Oldtown Bridge was completely restored using most of the original materials. (Jurgensen photograph.)

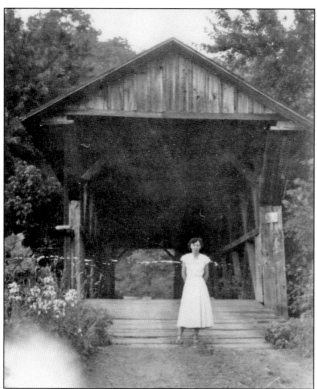

CARTER BRANCH BRIDGE. A Miss Glass is shown standing before this rare Wheeler truss bridge on Deer Lick Branch Road over Little Blaine Creek in Lawrence County. Carter Branch and the surrounding community were named for Thomas Carter. The covered bridge was lost in a flood in 1942 and replaced by a steel camelback pony truss. The site and surrounding area is now under Yatesville Lake.

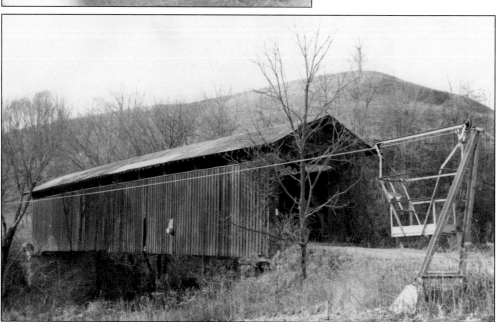

CABLE CAR AT YATESVILLE BRIDGE. This mid-1960s view of Lawrence County's last covered bridge shows the cable car that ran parallel to the 110-foot Howe truss. Rumor that this conveyance was to allow residents to cross Blaine Creek during high water is untrue, although it was used unofficially for this purpose. The cable car was for U.S. Geological Survey flow readings of the stream. The box mounted to the side of the bridge is part of this equipment.

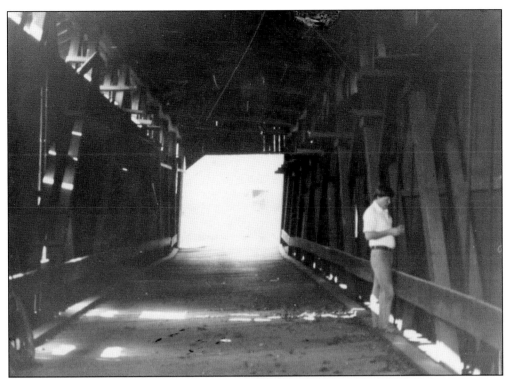

YATESVILLE BRIDGE. R. W. B. Laughlin, P.E., inspects the trusses of the Yatesville Bridge in 1976.

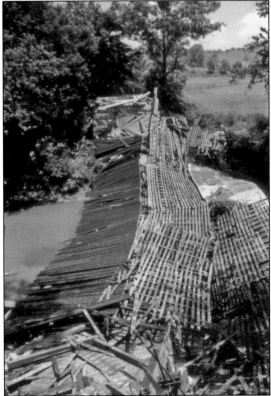

LIFELESS YATESVILLE BRIDGE. The last of three known covered bridges in Lawrence County, the Yatesville Bridge on the Yatesville-Cadmus Road was saved from demolition by a letter-writing campaign begun by KCBA's L. K. Patton and Paul Atkinson in 1965. The 110-foot Howe truss was bypassed, repaired, and repainted blood red. In May 1986, the bridge collapsed into Blaine Creek, and the remains were removed by the County Road Department. (Todd Clark photograph.)

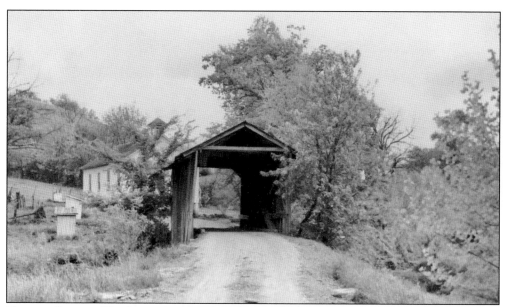

TRINITY BRIDGE. The last authentic covered bridge built in Kentucky was Lawrence County's Trinity Bridge over Little East Fork in 1924. In the background is the one-room Trinity School. The bridge was replaced in 1981. It was Kentucky's youngest covered bridge, but the well-built Trinity Bridge always gave the appearance of being in a bad state of repair, as evidenced in this 1965 photograph.

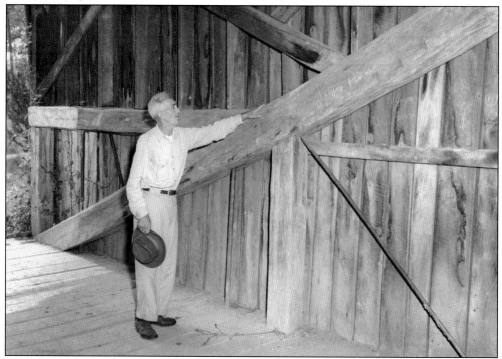

TRINITY BRIDGE CRAFTSMAN. Kentucky's youngest covered bridge was built by John and George Riffe. John Riffe examines his handiwork in 1951. (Courtesy Transylvania University Library, John Thierman Collection.)

Ten

LEGEND, LIE, MYTH, MISNOMER, AND MORE

Kentucky is a land of many legends. Its name is from the old Iroquois word Ken-Tah-Ten—meaning either "the land of tomorrow" or "the dark and bloody ground." Throughout the forgotten communities, abandoned schools, and crumbling antebellum estates abound tales of ghosts of soldiers, spectral trains, green glowing lights with no apparent source, and even haunted covered bridges. These tales of wraiths are often coupled with "facts" that have passed through the years as gospel.

In the 1920s, a postcard was produced of the bridge at Butler carrying the caption "Longest Wooden Covered Bridge in the World." As recently as 2004, this myth appeared as fact in a newspaper article. In actuality, Butler was the longest covered bridge ever built in Kentucky but was never the world's longest. If standing today, the 456-foot Butler Bridge would be four feet shorter than the longest covered bridge currently standing in the United States.

The 240-foot, single-span Wernwag truss at Camp Nelson was significant as one of only two highway bridges over the Kentucky River during the Civil War and its position near the Union post made it militarily strategic. One myth that continues to this day is that the bridge was originally designed so that removing one bolt would cause the entire structure to collapse and not fall into enemy hands. Many a young man enticed his date to give him a forbidden kiss by simply offering that if she did not remove her hesitations, he would remove the bolt.

Another myth was furthered many times by the authors and was only recently debunked: For years, it was believed that the King's Mill Bridge was inundated by the Dix River when Herrington Lake was formed in 1926. Recent discoveries have proven that this was not the case.

Kentuckians are proud of their derby, their bourbon, and their pioneer heritage. Given the truth, many will hold steadfast to these canards, making the dark and bloody ground, at least in the forum of covered bridges, less a land of tomorrow but truly a land of legend, lie, myth, misnomer, and more.

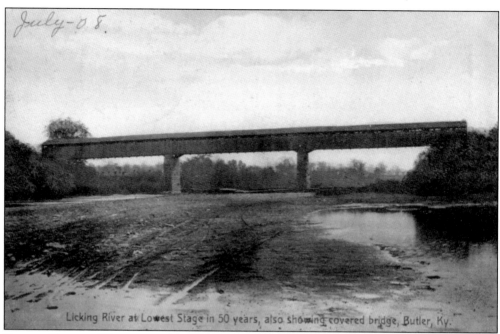

July–08.

Licking River at Lowest Stage in 50 years, also showing covered bridge, Butler, Ky.

BUTLER BRIDGE. This postcard, postmarked July 1908, shows the Licking River at its lowest stage in 50 years. The image shows very clearly how high were the piers, but it was never the world's longest.

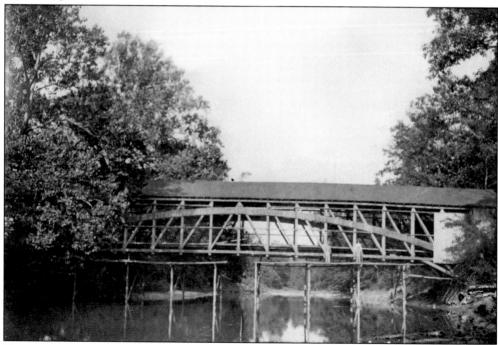

UNIDENTIFIED COVERED BRIDGE. This Bower Bridge Company photograph was made c. 1905. At this time, the Bowers were active in central Kentucky. The general topography of the site, length of the bridge, and distance above the stream compared with the extant iron truss at the site suggest that this may have been over Boone Creek near Plum at Gillespie Road in Bourbon County.

UNIDENTIFIED COVERED BRIDGE. This old postcard view is captioned only as "A Bit of Blue Grass Scenery." H. H. Phillips Drugstore in Winchester, Clark County, Kentucky, commissioned the card; however, it is not necessarily a Clark County bridge. The topography suggests that it could have been in Scott County over Ray's Fork on the old alignment of U.S. 25 north of Georgetown. (Courtesy Todd Clark.)

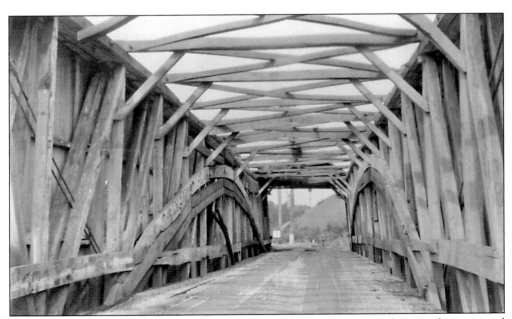

UNIDENTIFIED COVERED BRIDGE. A c. 1925 Bower Bridge Company photograph is stamped "Leo Chrisman 'Fotographer' West Second Street Maysville, Kentucky." The exact location has not been identified, but it does not visually reconcile with any of the 19 known Mason County covered bridge locations.

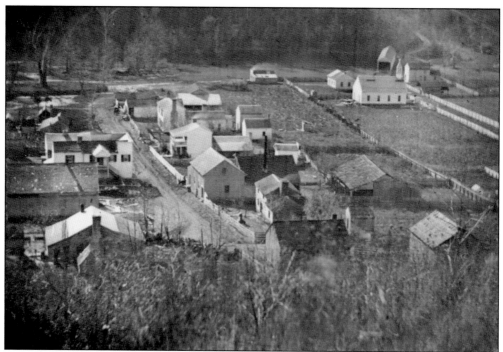

UNIDENTIFIED COVERED BRIDGE. This is a Williams Studio photograph of an unidentified community and covered bridge believed to have been in Shelby County. (Courtesy Jim Cleveland.)

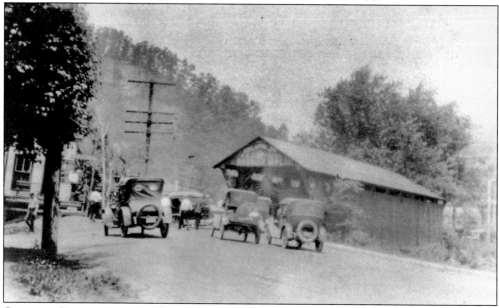

GREENUP COUNTY BRIDGE. This 90-foot Wheeler truss is shown during an automobile accident *c.* 1920. The exact location is unidentified but is believed to have been over Raccoon Creek at W Hollow. If so, this bridge was standing in 1937 but had been replaced by the late 1940s. A later photograph of this same bridge was misidentified as Ohio's Hanging Rock Fork Bridge, also a Wheeler truss. The prominent ridge in the background still marks this location on KY 2. (Courtesy Greenup County Library.)

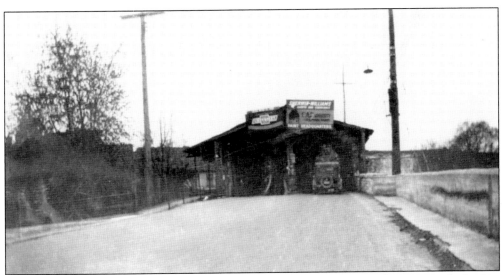

COTTONTOWN BRIDGE. Reportedly a local resident was last seen one night entering the bridge; however, no evidence of his fate was discovered at the time. For years, white "globes of light" were seen bouncing from the floor to the rafters at this end as travelers entered at the other from Paris. The lights disappeared as they were approached. The legend continues that when the bridge was dismantled in 1933, one of the overhead timbers was discovered to have been hollowed out and the skeletal remains of the missing man were found.

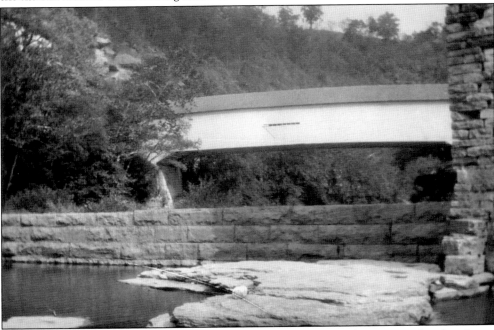

KINGS MILL BRIDGE. This bridge has long been the point of speculation treated as fact. It was for many years thought that the bridge was left in place after the construction of Dix Dam and was inundated by Herrington Lake. In 2006, a contract between Ed and W. T. Niekirk and the Kentucky Hydro Electric Company from June 1925 was discovered, detailing the process to remove the bridge and distribute the timbers between Boyle and Garrard Counties. (Courtesy Filson Historical Society, Louisville, Kentucky.)

DISCOVER THOUSANDS OF LOCAL HISTORY BOOKS
FEATURING MILLIONS OF VINTAGE IMAGES

Arcadia Publishing, the leading local history publisher in the United States, is committed to making history accessible and meaningful through publishing books that celebrate and preserve the heritage of America's people and places.

Find more books like this at
www.arcadiapublishing.com

Search for your hometown history, your old stomping grounds, and even your favorite sports team.

Consistent with our mission to preserve history on a local level, this book was printed in South Carolina on American-made paper and manufactured entirely in the United States. Products carrying the accredited Forest Stewardship Council (FSC) label are printed on 100 percent FSC-certified paper.

MADE IN THE USA